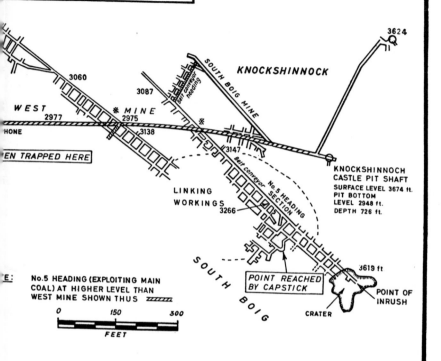

NK COLLIERIES

KNOCKSHINNOCK

3624

SOUTH BOIG MINE

3060

3087

WEST
2977 * MINE
2975

HONE 3138

EN TRAPPED HERE

3147

Belt conveyor heading

KNOCKSHINNOCH
CASTLE PIT SHAFT
SURFACE LEVEL 3674 ft.
PIT BOTTOM
LEVEL 2948 ft.
DEPTH 726 ft.

LINKING
WORKINGS
3266

No.5 HEADING SECTION

Belt conveyor

SOUTH

BOIG

E: No.5 HEADING (EXPLOITING MAIN
COAL) AT HIGHER LEVEL THAN
WEST MINE SHOWN THUS ▨▨▨

3619 ft

POINT REACHED
BY CAPSTICK

POINT OF
INRUSH

CRATER

0 150 300

FEET

DIAGRAMMATIC SECTION THROUGH SUPERFICIAL DEPOSITS BEFORE INRUSH

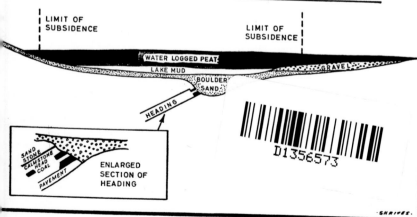

LIMIT OF
SUBSIDENCE

LIMIT OF
SUBSIDENCE

WATER LOGGED PEAT

LAKE MUD

GRAVEL

BOULDER
SAND

HEADING

SAND
STONE
CALMSTONE
HEAD
COAL

PAVEMENT

ENLARGED
SECTION OF
HEADING

D1356573

SHRIVES.

BLACK AVALANCHE

Arthur and Mary Sellwood

The authors of this book learned the truth about the disaster from the men and women who endured the dangers, the responsibilities and the strain of the fantastic episode. For the heroism shown at Knockshinnoch two George Medals were to be awarded; and Sir Andrew Bryan, the Chief Inspector of Mines, was later to say: "There is nothing in mining history in this country to equal this achievement".

Yet, even while the world applauded the rescue-heroes and mourned the dead, a searching enquiry into the causes of the tragedy was already under way. Its findings were to be as astonishing as they were dramatic.

Tense and moving—*Daily Mirror.*

Other books by
Arthur Sellwood

DYNAMITE FOR HIRE
ATLANTIS (with Ulrich Mohr)

both Howard Baker Books

BLACK AVALANCHE

Arthur and Mary Sellwood

HOWARD BAKER, LONDON

BLACK AVALANCHE
Arthur and Mary Sellwood

© Arthur and Mary Sellwood, 1960

Originally published in Great Britain by
Frederick Muller Ltd., 1960

This Howard Baker Edition, 1970

SBN 09 300440 0

A HOWARD BAKER BOOK

Published by
Howard Baker Publishers Limited
47 Museum Street, London W.C.1

Printed in Great Britain by
J. W. Arrowsmith Limited, Bristol BS3 2NT

CONTENTS

Illustrations

PRELUDE TO AN AVALANCHE

THE tunnel was hungry—was biting through the Main Coal at the rate of nine feet per shift. The tunnel was rising—was soaring so steeply, as it followed the upthrust of the seam, that the floor beneath Dan Strachan's heavy boots sloped back to the pit-bottom at a gradient of one-in-two. From the shaft to the face it was one continuous climb: but Strachan hardly noticed it.

Fireman Strachan had been with the tunnel from the moment they had blasted it from the colliery's vast womb, and it had grown upwards at a gentle one-in-seven. He had been with it when—only a few months later—the angle of incline had abruptly steepened. Its lusty surge towards the surface had quickened. Now, after nearly a year, Dan Strachan sometimes considered that he and the tunnel were involved in a sort of partnership. He had climbed with it since the beginning: he was climbing with it now: he would continue to climb with it until its precocious growth was halted.

Just when would that be? He had no idea. There had been speculation, but nobody *knew*.

The tunnel was eighteen feet wide by ten feet high: thriving, never resting, pet of the pit development plan. From the depths the tunnel had climbed for half a mile. Cave-like openings in its walls gave access to a labyrinth of workings. In front of Dan Strachan scowled the face, to judge by its appearance impregnable, yet forced by him daily into fresh

retreat; crumbling and yielding ground to the tunnel's fast advance. Behind him, the darkness of the slope—a night without stars.

It was a noisy place, the tunnel; noisy as they go. There was little respite from its persistent clamour, from the clang of shovel-steel on dirt, to the jerky chatter of the conveyor bearing the coal down to the distant loading point. This harsh symphony accompanied every effort of Dan and his mates; a next to non-stop affair, played almost continuously through three eight-hour shifts. It was only the occasional silence that they hated—the rare silence that might follow a minor mechanical hitch—for in the silence, the tunnel was like a tomb. It was called No. 5 Heading at Knockshinnoch Castle Colliery.

Knockshinnoch was booming, as everyone agreed. Crouched at the foot of the Kircudbright Hills, it sprawled in red and white brick on a hillock of its own, above the township of New Cumnock. Employment was given to over 700 people. Mechanized and progressive it yielded for every week of fifteen shifts 5,000 tons of coal. As with all good success stories, its theme was rags-to-riches.

Only twelve years had passed since the diamond-tipped drills of a prospecting team, probing deep into the strata of the "dying" coalfield, had ceased to snarl shrilly on worthless rock and gravel. All at once they whirred smoothly into untapped reserves of wealth. Twelve years . . . the district had been transformed . . . brought from its potential death-bed to surge with health and vitality.

Coal in abundance, millions of tons of it! The thrill of the first "find" never would be forgotten. The young men had been halted in their drift to other industries. A housing scheme was started to provide for an influx of new workers. A group had been sent to America to study mechanization.

In 1940 they started to build the new Knockshinnoch Castle.

To meet the demands of coal-hungry war-time Britain, new blasting technique were used to sink the Main Shaft—brick-lined and straight as a rifle barrel—to a depth of 720 feet. Begun on the site of the old Knockshinnoch No. 2, abandoned seventy years before, it symbolized New Cumnock's change of fortune. From the pit-bottom, they next drove the West Mine —boring through the rich earth at record speed, and machinery not used in Scotland before was employed to assist progress. In fact, the first mining machinery to be assigned under Lease-Lend. Knockshinnoch's subsequent advance had been un-broken.

By Vesting Day 1947, "The Castle" was one of the best equipped collieries in Britain. By spring 1950, its fingers spread in all directions of the compass. Fingers that reached upwards and sideways to filch deposits of the laden seams. Now, in September, there was talk of still further progress. How the South Boig section was to be additionally exploited: and as part of this one of the colliery's most promising districts, No. 5, was being blasted towards the heights.

No. 5 was thriving. Much was expected from it. Its produc-tivity was as impressive as its wealth. Small wonder if, like the Castle itself, and the men who made the Castle, it was eager, aggressive, and, maybe, cocksure.

"Remarkable," said an official, reflecting upon the way the colliery's glittering harvest was being gleaned from beneath the stubble of the bleak Ayrshire fields. "Remarkable" it was, and in a sense which he had not considered. But for Strachan, on this late autumn morning, there was no time for superlatives. Professional, taciturn, he was completely absorbed in his job.

It was 10 a.m. on Wednesday, August 30th, 1950. With the unhurried deliberation of the experienced man he placed a gelignite charge into one of the shot-holes that had been bored into the face. Then, having assured himself as to the

safety of his section, he retired equally unhurriedly a short way down the slope.

He had done this so many times before: awaited the explosive expulsion of coal from the slab-like face. His thoughts and actions were almost automatic. First (at the distance prescribed by regulations) he flopped on to the floor, bolstering himself comfortably against the wall. Next, pulling the explosives box towards him, he cast a last all-embracing glance over the slack wire stretched from box to shot-hole. Satisfied that all was according to the book, he turned his head slightly, to avoid flying splinters, and, pressing his grimed hands downwards, drove the plunger home. . . .

Such a simple job—when you knew how. A minute, almost infinitesimal part of the pattern of the pit. One action among the hundred and one daily performed in the darkness of Knockshinnoch; each man's contribution of equal importance to the fate of this colliery. Though Strachan could not know it, the outcome of his conscientiously performed task was to send tragic echoes resounding through the world.

He had signed not only his own death warrant, but that of the tunnel too. He and No. 5 had but a week to live.

"In some respects," they said, "No. 5 was a bit of a mystery."

It had started as a gentle slope. As you turned into it from the belt heading after the trudge from the cage the gradient was hardly noticeable. Now it dragged the breath out your lungs . . . might as well be a mountaineer! Why all the uncertainty as to where the thing would finish? Was it a fact that No. 5 might go straight through to the surface?

Despite speculations, few of the men were much concerned as to the tunnel's destination. Certainly they never considered that its erratic climb might constitute a threat to their safety. Ayrshire coal seams seldom lay neat and level. Geological disturbances, created before history, had broken the strata;

concertinaed it, sandwiched it between thick layers of dirt. The seam rose or fell in steps—some broad, some extremely narrow. When the seam climbs, so must the miner. In Ayrshire they have a phrase for it—"you must drive your road to catch your coal."

Was not the Castle's adoption of this practice just a little extreme? Also was it not unusual, to be so far on with a job yet not know where you would finish?

Canteen comment showed interest without alarm. The management *must* know—or at least they *ought* to do so. Doubtless they would pass the word around to whoever did not. The face of No. 5 was by now so close to the surface that surely an announcement must be imminent.

"Our's not to reason why," gibed one miner, when asked if the heading might not be surfacing as an airway to improve pit ventilation.

Luckily, perhaps, he did not know the next line of the poem.

The echoes of the shot died down. The tunnel was quiet again. Strachan toiled back up the slope to study the effect; then stared again—astonished.

The glow of his helmet light revealed a large brown patch—two feet wide by five high—scarring across the black of the coal. Curiously he prodded the texture with his square-nailed fingers. The floor was littered by a mass of tumbled coal. In fact he was ankle deep in it. But this fall was *different*. And Strachan knew it. One final prod confirmed his quick suspicion. The pattern behind was a mesh of stone and gravel!

A few seconds later came water, springing from the shot-hole like blood from a deep wound. He called for the oversman.

In the course of the next week many others were to see that water; became used to seeing it. Now as it flowed down the heading towards the pit-bottom, it was clear, crystal clear. All were agreed on that. Opinions varied only as to its extent. One

miner saw the inflow as similar to that produced by "a two-inch pipe". Another, as "a good wee run . . . but nothing to be feart of". A third considered the flow "just a trickle".

What did Strachan think? His opinion was never recorded. When questions came to be asked at the time of the official inquiry, he was powerless to give evidence, having been among the broken tunnel's dead.

The shifts changed. Thursday dawned and still the water flowed.

"The heading has holed through on the outcrop of the seam," the men going "inbye" were told. Beyond a terse "aye" there was little reaction. Ayrshire miners are not lightly moved by novelty. The men of No. 5 conformed to type.

"Look, *that* must be the water they're talking about," said one, pointing.

"Well, it's no as broad as the Clyde," replied another.

They resumed their mission of coal-getting.

As soon as the oversman received Strachan's report he inspected the face, then informed the manager, William Carlyle Halliday.

"I'll come down and see for myself," the latter answered, arriving within the hour.

Halliday's visit caused two departures from normal routine. He ordered that a pair of chocks be installed as a precaution against falls from the roof. He also recalled the men from the face—setting them to work in the "stoops" (chambers opening from the sides or the heading). Apart from that, it was pretty well business as usual.

However, up top, in a field of Knockshinnoch Farm, Tom Wilson's cows had paused from ruminating just long enough to regard the first of a series of unexpected distinguished visitors. The rain had ceased. Visibility was clear. But these gentlemen who had strolled over from the pithead were occupied with more weighty matters than the weather. In fact, the sprawl of

the colliery at their backs and No. 5 heading beneath their feet.

Though theirs was a business visit it was neither inspired by nor directly related to the situation in No. 5. To them no "situation" existed. Officials all, John Bone, local agent, Donald Mackinnon, assistant sub-area planning engineer, and Manager Halliday had more important considerations than the cause and effect of a flow of water which, judging by its clarity and consistent volume, came from a safe covering of rock and stone. Halliday had provided those chocks, so he and his fellow administrators could turn to broader issues.

They wandered through the field, their minds busy planning the future. They were anxious to pinpoint the place where the airway would emerge. Should they make No. 5 this airway? They wanted to see how far this was from the surface, in case, of course, they decided to drive it to the surface. Any idea that the inflow—"trickle" or no—could jeopardize these far-reaching plans would have seemed fantastic. Fantastic as the notion that the ground they so confidently trod was anything else but innocent turf.

T. D. Brown, senior assistant surveyor for the Sanquhar and New Cumnock colliery groups, busied himself taking levels and measurements. In passing he noted that the field was a pasture, with "nice green grass".

Bone Halliday and Mackinnon thought it was "good agricultural soil". Had Farmer Wilson been consulted he might have told a different story. Explained why this "fertile" area had been left uncultivated. His reason for abandoning it to his cattle. But Wilson was not asked.

Apprentice surveyor Ian Murray was sent to the face to examine the cover between the heading and the surface. Back in June the nearest extremity of No. 5 had been nearly 200 feet below. Now he discovered that the distance had narrowed to thirty-eight.

Young Murray's next job was to mark in the field a point that would be immediately above the face of the heading. He

used a two-pound blacksmith's hammer, surprised to find how quickly and easily the two-foot peg slid into the earth. Apart from this Murray noticed nothing unusual. The ground was "a wee bit soggy", probably because of the rain.

Saturday came and part of Knockshinnoch's population went to a football match. Sunday came and many more went to church. On Monday the morning shift in No. 5 found that the water still was flowing.

It was just as clear and cold. There appeared no difference in the rate and volume of flow. Work continued in the "stoops", the face remaining deserted. By Wednesday the changing shifts were taking hardly any notice of the water. It had become part of the landscape.

And then—quite suddenly—the water began to increase.

I

THE FIELD AND THE FALL

IT was raining. A chill, grey drizzle had given place to a fierce downpour. With the wind behind, it was clouding the straggling street beyond the window-pane and scattering the pale smoke from the chimneys of the houses opposite. The date was Thursday, September 7th. The time—approaching that of the back-shift.

The King had arrived at Braemar, the Security Council vetoed a Russian resolution on Korea and the TUC was discussing Attlee's plea for wage restraint.

Houston laid aside the newspaper, his attention on the weather. This he regarded with the depressed interest of one who shortly had to venture into it. At the same time he spared a moment to wonder how his wife, Mary, was faring at the Women's Institute outing. Just her luck, Andrew Houston reflected, to have picked a day like this!

Fallen leaves, shapeless and sodden, were plastered against the pavement. A multitude of fingers seemed to drum on the grey slate roof. The wind's force was increasing, whipping in from the sea . . . For a second or so longer he continued to consider the scene and then, looking at the time, shrugged resignedly. He uncurled his long legs, hauled on his boots, picked up his piece-box containing bread and cheese. Having wrapped himself up against the elements he set off on his accustomed journey to the pit.

Except that Mary had not been around, Andrew Houston's

departure from his home at Pathhead, New Cumnock, had been as regular as ever. Familiar as the feel of his pit helmet, or the ordered flow of the heaped conveyors, rhythmically, endlessly, progressing through the thick black veins below. As he confessed with candour, he was largely a creature of habit. A chap who liked things tidy.

"Oversman's left, lad," said a miner's mother, watching through the curtains the tall, lean figure brace itself firmly against the gale. "Best take the hint!"

"Yon Houston's that punctual you could set your clock by him," protested her son, pulling up his socks.

Each day for the past six years Andrew Houston had left his home at precisely the same time. Always ahead of time for the shift that began at 2.30 p.m. Each night for the past six years he had come back, just as punctually, around eleven. He had been the oversman of the back-shift since 1944 and was in operational command of 129 men.

Strict and efficient, possessed of a dry humour, a fact betrayed by the quizzical grey eyes that belied so strikingly the solemnity of his face. Even the slackers liked him, though they could not say exactly why.

"Well, one thing about him," conceded the young miner's mother, "he's an honest man and a fair one. Moreover he works hard for his living."

"Aye, that's true enough."

It was Thomas McDonald, the day-shift fireman, who first reported the increase of the flow through No. 5. He noticed it around 9 a.m., five and a half hours before Houston's men were scheduled on duty.

The flow was at least twice as wide as the previous day. Some of the men who saw it claimed that it was three times as wide.

McDonald promptly notified his oversman, who arrived at 9.30 a.m. to inspect the face from which the water sprang.

For the day-shift men in No. 5 a rather frustrating period lay ahead.

They would be even more glad than usual when the back-shift took over.

"A national scandal, *that's* what it is," said one of the workers as the bus made its jolting progress towards the Castle.

His mate looked puzzled. "Eh? I don't follow you."

"The price of coal, man, it's a national scandal. That's what some bloody reader says in the paper. It's our wages to blame, he says!"

The reply was unprintable.

Selfish men, lazy men, spendthrifts who chucked their easy money over the nearest bar . . . they all knew what *some* folks thought of them. They blued the nation's resources in chara-trips to football matches, or invested in household frills such as cocktail cabinets and washing machines. They wanted a shorter week, more pay, in fact—the earth.

"Hell," continued the man who had spoken first. "It makes me ruddy well sick!"

Yet few of the back-shift men were concerned at the moment with current social history. Most of them were discussing the St. Leger, to be run on Saturday. One man was perturbed because he had not posted his football coupon.

"Why worry? It'll be all right if you get it away in the morning."

"Maybe," said the other dubiously. "But I always like to make sure."

Not all the Castle's company travelled by bus from New Cumnock. Some of them lived near by.

As they reached the entrance to the colliery the rain lashed into the faces of these shabby members of the back-shift, trudging untidily through the widening puddles. There were old, gnarled men among them; men who advanced steadily,

with silent bitterness, heads bent low against the weather . . .
men who exchanged their greetings in the briefest mono-
syllables; grateful to relapse again into independent solitude.
There were also young chaps, larking; pushing each other
around, talking about the Cumnock Picture House, sharing a
joke.

"Flow gently clear Afton," one of them sang with irony.
Even the dourest of the elders complimented him with a tight-
lipped smile.

Knockshinnoch is in Burns's country. On its small hill aloof
from the slate-roofed miners' dwellings, it was built when the
Industrial Revolution came to Ayrshire, turning the fresh grass
sour. The place squats between the Nith and Afton, on the
slopes of Dalhanna. In the hot summer months neighbouring
New Cumnock derives some profit from its associations with the
poet. Its mining community is livened by the arrival of
holiday-makers. Men from the wid-west, wearing picturesque
tartans, add colour and cadillacs to an unpicturesque main
street. But today the Knockshinnoch scene belonged to the
men who lived and worked there. Men with cloth caps and
mufflers.

"Flow gently clear Afton, among thy green braes."

As the back-shift saw the Afton, it was very far from "clear".
Yellowed with the earth washed down by the rain, its tide
carried a litter of rusty tins and tangled straw. The water
surged gloomily against the top of the bank, as if threatening
to spill.

Houston thought : "Just Mary's luck to have a wretched day
like this for her outing."

A day like this . . .

Among the men of the back-shift were fathers, fathers-to-be,
lovers and sons. Bevin Boy Gibb McAughtrie had left his
eighteen-year-old bride of the previous year looking after their
new-born baby at their home at Dalmally Road. Salvationist

John Dalziel, of Lyme Road, was the father of nine. To the wife of Willie McFarlane, of Football Road, a child had been born that morning. Walls Walker envied Willie: as an expectant father himself, he found the strain of waiting beginning to rattle his nerves.

The slag heaps loomed up through the sombre afternoon like brooding giants. The steam from the winding-house spread outward over the pithead, as though pressed down by the weight of the clouds above it. A drear, chill scene. But Willie McFarlane was happy, his wife was doing nicely, the baby looked fine. Tonight he must celebrate.

McFarlane was to work just off No. 5 heading. Next to him would be James D. Houston—the oversman's younger brother. The two men formed part of a group controlled by Fireman Dan Strachan.

It would number 13 ...

The morning's shift in No. 5 had achieved an all-time low in production. Since Fireman McDonald's first report of the water's increased flow, a series of mishaps had marred routine.

When the day-shift oversman first inspected the hole he had found it wider. More coal had been dislodged from the face, even though the stones at the back of the hole appeared to be packed solidly as ever. The oversman worried in case the water entered some of the side workings, therefore he ordered a gutter to be dug to confine the flow to the heading.

Later the under-manager arrived. He, too, was concerned with the problem of keeping the working places free from interruption. The two men spent several rather anxious moments discussing the capacity of the pit pumping system. That the water might contain an element of danger occurred to neither of them. On the basis of the evidence then available, there was little reason why it should.

Then came a further interruption. A conveyor belt, stretching down the centre of the heading, to shift the coal that

was hand-loaded from the workings, stopped. Inspection showed that the water had washed away some of the displaced coal into the mechanism of the belt. No sooner had the coal been cleared than the machine seized up again and men were set to work to free it. Their success was only temporary, the water, white-flecked, carried fresh burdens of loose coal down the slope of the heading. Soon the conveyor belt operated only in fits and starts. By now a regular stream, the water was watched by a group of miners, made idle by circumstances.

The climax of the day-shift's unhappy experiences was reached in the early afternoon. Over the previous week six chock pillars had been installed in No. 5, to supplement the pair that were built on the actual day of the holing. Now without any warning the two nearest the face gave way. The startled shift agreed that the water must have undermined them . . . scooping away the supporting dirt.

The oversman reported this to the under-manager in the presence of Bone, the agent, and Mr. Arbuckle, the surveyor. None of the trio expressed undue concern.

Meanwhile the shifts had changed over. Houston's men were installed in the labyrinth of the pit.

As middle-aged Pup Walker set out from his home in Craigie Avenue for the miners' welfare meeting at Dalmellington, he reflected, by no means for the first time, that the public-spirited sometimes had a lot to bear. Being uncomplaining, he kept these thoughts silent. Walker even felt a certain shame at having conceived them. Though he loved the job, on this particular afternoon there were disadvantages in taking so prominent a part in the district's social life. The weather made him long for the warmth of his own fireside and the singing of the kettle, always on the hob.

Pup Walker was a quiet-seeming man of mining stock associated with the Ayrshire seams throughout the Scottish coalfield's chequered history. Like his grandfather before him

he had six sons. Also like his grandfather, he had seen all six earn their living underground.

As Pup boarded the bus he thought of those sons, all workers in Knockshinnoch. James, Archie, and Willie were off duty. The other three were on the back-shift. Tom was driving a joy-loader, Walls running a diesel loco which carried coal between the West Mine and the shaft. Teenage Alec, the youngest, was a pit boy.

Alec was the only boy still lodging at home. Pup found himself quite unexpectedly dwelling up on the past; times when the walls of the small house had seemed ready to burst from the energies of the young people behind them. Six sons, three daughters . . . a regular quiverful.

"Hear you're going to be a grandfather again, Pup," an acquaintance said cheerily.

He nodded. "Aye, any day now."

The hours went by, the rain increased. Below the stream gurgled noisily down the heading. Up top the water lay in great pools, as though no outlet could be found for it to drain. Wind bent stunted trees before it, twisting them like diviners' rods towards the earth. In the lamp-room Andrew Houston was impressed by the increasing volume of the gale; its thunder impinged on his calm routine. In the canteen workers pressed their noses against the windows, scarcely able to see out for the glistening globules that rolled across the glass.

When the pit telephone rang Houston idly noticed the time. It was 6.30 p.m.

"Number Five's fireman asks if he can see you."

Houston answered, "Okay. Tell him to come on towards the pit-bottom. I'll go down to meet him there."

As he stepped into the winding-house and took the next available cage someone remarked, "That bloody heading again . . . there's been nothing else but trouble!"

It was cold and very noisy at the bottom of the shaft.

Stepping briskly past the loaded tubs, delivered by Walls
Walker's loco, Houston met Strachan fifty yards farther along
the road.

The fireman's face was nigger-minstrel black beneath his
squat helmet. When he slapped his palm against his overalls,
they threw up a cloud of coal dust as fine as talcum power.

"Trouble?" asked Houston.

Strachan nodded. "A fall at the face of No. 5—a big one
this time."

"How far from where the men are working?"

"About three hundred feet."

Houston pondered before asking further questions. The roof
was holding firm; there were no further complications. All the
same . . . "What about the water? Has it become thicker?"

Strachan furrowed his grimed brow. "Funny that . . . seems
as though it's stopped."

"Oh?"

There was a brief silence.

Said Houston: "I'll go up to the surface and have a look
round at the point above the heading. Maybe with Number 5
so near the top we can get a clue or two from the look of the
ground."

"Right."

"I'll return to the section directly I've contacted the
manager."

The fireman hurried off towards No. 5. It was the last
Houston saw of him.

Strachan, hastening back to the tunnel . . . Houston to
Wilson's field . . . each oblivious of the threat above Knock-
shinnoch.

Until too late they were not to know the real nature of the
peril about to strike at No. 5. For they were not to know the
story—a strange one, too—of The Chart with a Missing
Symbol. . . .

In Halliday's office at Knockshinnoch Castle was a large chart, supplied by the Sub-Area Planning Department in April, 1950, it related to the development of No. 5. The part coloured blue on the drawing forecast "the expected progress" of the section up to September 1st. Another portion, orange coloured, showed "the progress expected until February 1st, 1951". A neat looking job; impressive, perhaps, to a visitor. However, to those who knew better, it was a completely wasted effort.

The chart had been drawn up on the premise that the gradient of No. 5 heading would rise to one-in-four. Actually the coal had begun climbing to one-in-two, the heading keeping pace with it. Long before September the chart was out of date.

Being human, planners were subject to mistakes. In attempting an advance estimate of the shape of contours below ground, they have a particularly thankless task. However good their vision, they work in the dark.

It happened that at Knockshinnoch this simple miscalculation of the slope's gradient, which may have arisen from somebody's disagreement with, or ignorance of, the commonly held belief that coal seams rise towards a rising fault, was to lead to a further error. This was regarding the precise point at which No. 5 heading would cease to advance.

Carrying the one-in-four theory to its neatly pencilled conclusion, the chart's authors anticipated that the heading would reach to the Southern Upland Fault. This was a vast granite layer lying south of the colliery. There, it seemed to them, it would finish with a hundred feet of solid cover between it and the surface.

No. 5 had done nothing of this sort—by rising to one-in-two it was rearing up at a point far short of that which the plan indicated. As young Murray had discovered, only thirty-eight feet now separated the heading from the nice green grass of Wilson's field.

Nationalized industry planners are perpetually attacked,

accused of being too prodigal over distributing material. Their equipment is said to be too lavish. This was untrue of Knockshinnoch.

That plan in the manager's office was neither so elaborate nor detailed as those plans "drawn on linen" housed in Sub-Area HQ. It was later revealed as "a rough tracing in draft", not seen even by the Sub-Area Planning Engineer, whose department had issued it. The Planning Department of the Sub-Area 8 (East Ayr) of the Scottish Division of the NCB was no omnipotent governing body. It merely provided "service" in an "advisory" capacity. Not that anyone worried about *that,* anyway before September 7th . . .

To Bone, Halliday, and several other officials, the fact that the actual heading—as distinct from its paper forecast—was nearer the surface than the plan allowed for, was "old stuff". So much so that they never bothered to tell the authors of the chart.

What Bone, Halliday, and the others did not realize, as they debated the wisdom of capitalizing on the steepness of the seam by turning the heading into a return surfacing airway, was that the Geological Map at Sub-Area (the *only* free issue from the Coal Board) contained a small but very clear symbol lacking from the document given to Knockshinnoch by the planners.

This symbol described the state of ground into which No. 5 was thrusting, in one short, forbidding word . . . PEAT!

Emerging from the pithead, Houston walked over to Wilson's field, almost immediately finding the evidence he sought.

Part of the surface had sunk, it lay two feet lower than surrounding soil.

Subsidence was not unfamiliar to Houston. Ayrshire earth was pockmarked by "sits", as they are called in mining jargon. A "sit" was nothing to cause alarm. Not when you had known

about them for over two score years. On the other hand this one was a hell of a size.

Almost automatically his training enabled him to assess the hole's dimensions. Twenty-five to thirty feet long . . . ten to fifteen broad. He returned quickly to the colliery.

William Carlyle Halliday had taken the day off : a well deserved break.

Devoted to the service of the Castle, enthusiastic about the productivity campaign, he drove himself hard, taking his managerial job very seriously. It was typical that he should have spent the whole of August Fair Week, when the miners went on holiday, drawing up plans for the well-being of the colliery, in general, and, lately, for the future of No. 5.

No. 5 was becoming a special interest of Halliday's, he followed its progress with almost paternal pride. He was sensitive, too . . . prone to worry about his responsibility. Experienced and cautious. Yet answering Andrew Houston's telephone call, the manager's concern at the oversman's news was not created by fear of trouble underground. Neither he nor his caller saw cause for alarm over the future safety of Knockshinnoch. Halliday's forebodings were quite different.

A right of way existed across the field. In the dark the hole could be dangerous to pedestrians. As Halliday and Houston both knew farmers had an unpleasant habit of claiming damage from the NCB, especially regarding animals. And Wilson's cows grazed near by !

"Best get a fence up," suggested Houston.

With memories of how similar problems had been coped with at the previous pit where he had worked, Halliday said : "You'd best get that fencing started right away. If you can't find sufficient surface helpers, bring some men up from the pit."

"Okay," answered Houston.

One of the three men he called upon from the depths was handy Andrew Cunningham.

Light-framed, wiry and agile, dark-complexioned Andrew conformed more than most in Knockshinnoch to the outsider's idea as to how "the typical miner" looked. Only his sensitive lips betrayed the dreamer.

Cunningham's dreams mostly concerned his children, Anne and Billy. They were doing extremely well at school, he looked forward to them making a good career for themselves. Self-contained and taciturn, Andrew Cunningham was contented with his lot. A conveyor-shifter at present, he could turn his hand to most of the jobs below. His forebears had been miners. Still he wanted Billy to be different. Nowadays there was plenty of scope in the coalfields for young men with brains. Surveyors . . . pit architects . . . accountants . . . jobs preferable to the backbreaking stint in the dark.

Margaret Cunningham—competent, good-natured, shining their small house like a mirror—agreed with her husband's view. Yet that very morning when he had been congratulating himself that Billy was not showing the slightest interest in the pit, she had said, surprisingly, "You never can tell, Andy. Mining is in the blood."

Cunningham carried out his job efficiently. That still left time for dreams. In fact that was how he was occupied when Houston called him to the surface.

As Andrew stepped into the cage he had no idea that this routine assignment could provide the biggest break fortune had to offer . . . the break of a lifetime!

Conscientious as ever, Halliday began to fidget: day off or not, he felt he must see things for himself. On meeting Houston, however, he found that the latter already had concluded arrangements. Timber had been brought to the site, the five men of the fencing party had been set to work. The oversman

seemed to have the surface situation well in hand. "But I'd like to go underground now to take a look at No. 5."

Halliday nodded. "The roof may need some tightening . . . let me know if you want any timber."

Studying the hole the manager thought: "I'd better ring Bone to put him in the picture." It was a four-hundred-yard walk to the telephone. Annoyingly enough, the agent proved unobtainable.

When Halliday squelched back to the field several additional minutes had been lost. No one realized just how precious those minutes were. . . .

To the working party the hole meant "a bloody awful job" —nothing more. To the manager, the end of a cosy evening. Still, he was accustomed to demands upon his leisure. Going below, Andrew Houston was concerned solely with the "mechanics" of the situation. Trudging back from the stores, where he'd gone to fetch a hammer, Cunningham reflected that this surface stint made one's feet wet.

And then, with frightening speed, the hole went into a convulsion and the earth began to slip!

"Run, Andy! Run . . . !"

Snapping out of his reverie, Cunningham saw the working party scatter, stop, jump up and down and wave. Astonished by such behaviour and their cries to him, he also halted.

"Run, Andy! Run . . . !"

Now he saw the reason for their alarm. His blood seemed to freeze, his mouth tasted sour and felt dry.

He ran.

The hole was one no longer. It was Alive!

"Faster, for Christ's sake, faster . . ."

A whirlpool of madly twisting earth, sucking down bushes, turf, everything within reach—that was the hole now— hideously evil, a grotesque image of delirium. Cunningham's legs seemed weighted as he fled.

"Faster, faster . . ."

For a second he could feel the disturbance clutch at him. The shaking earth almost threw him off his feet and the soil's graveyard stench reeked in his mouth and nostrils. Trembling and ashen-faced, he joined the rest of the men.

"Dear God!" As if hypnotized he stared at the Thing—the way that it was spreading. The land seemed to protest against its greedy pull as the green grass slithered towards the slobbering maw. He thought, at this rate the whole field will soon subside. Vaguely he realized that Halliday was addressing him.

"I asked," repeated the manager, "if you'd go down the pit?"

Would he *what*? He could not have heard aright.

". . . Go down the pit to warn the oversman."

Go down below *that* muck? Go *below* . . .? Would he, Hell!

Cunningham's brown eyes smouldered. His sensitive lips hardened abruptly into a bitter straight line.

He answered, "Aye, I'll go."

The words were out before he knew that he had spoken.

The comfortingly cosy coach droned homewards over glistening, rain-soaked roads. Thoughts of members of the Culzean Castle outing affectionately turned to deserted husbands.

"I bet that Andy will be having a darned good laugh," joked Mrs. Houston, "picturing us paddling around like a lot of drenched hens. For one thing sure—*he'll* be out of the wet!"

Unaware of the havoc breaking out in Wilson's field, Houston alighted from the cage, walked along the pit-bottom and turned right, into the South Boig Mine. Loaded bins were on their way to the surface. A loco rattled back towards the conveyors.

The scene looked completely normal. Yet, he sensed suddenly, *something was not quite right.*

He branched into the belt heading, meeting John Dalziel. The burly Salvationist was busy loading coal. He only paused to grin then continued his work. *He* does not feel it, thought Houston, *but something unusual is about to happen.*

Farther on, where the heading joined the bottom end of No. 5, worked William Howatt, a switch attendant. Houston peered at him, vaguely questing, but had no response. Howatt also seemed completely absorbed by routine. This made Houston half ashamed of his own unease. Even so he hurried, as if prompted by compelling urgency. . . .

A blast of air heralded the tragedy. A blast that hurtled down the heading with such explosive force that it threw the oversman off his feet.

He was numbed by it, stunned by it, its echo filled his ears. When he rose again he was deafened and trembling. For a dreadful second hot panic surged over him. Suddenly, almost miraculously, his reflexes, long atuned to the pit and the trade of so many Houstons before him, readjusted themselves. His legs steadied, his brain became cold and clear. He began to run towards the source of the trouble.

John Montgomery came stumbling down the slope.

"What the hell's happening?"

"God knows," Houston panted. "It was okay up there when I left."

A third blob of light from a helmet appeared in the darkness. Its owner seemed in a desperate hurry. Sixty-eight-year-old James Haddow was the oldest man in the colliery. All his senses told him that this was the precise moment to leave it.

"There's something very wrong," he bawled. "The conveyor . . . there's something happening to it."

The rest of his sentence was drowned in a mighty roar. The conveyor belt began to slide—its whole framework moved with

incredible speed, recoiling past them, as though pushed by an invisible giant's fist.

"Come on," shouted Houston. "We must run for it."

It was eight o'clock. In the Afton Bank Hotel, just opposite New Cumnock Railway Station, four miners played dominoes. Stakes were not high but the men displayed deadly concentration—Ayrshire miners take their dominoes seriously. They were not to be diverted by frivolous conversation. Remarks were monosyllabic. Brows puckered.

As the wind fretted the telegraph wires and the rain beat steadily on the windows, a casual customer said to the quartet: "You fellows are the lucky ones in weather like this—spending your working day in a nice dry pit."

His nervous attempt at sociability was received with silent contempt. The dominoes clicked on.

Away at Dalmellington, Pup Walker was reflecting about this time that the main business of the meeting would not take long. Soon he would be home. At the moment he wished his bed still nearer. He would have been glad had the early shift been even more remote. Still, he was not ungrateful for small mercies. Pup was proud of his calling, especially the way it had been changed from the harsh and brutal slavery his great-grandparents had known. He was proud—excessively proud —of his six strapping sons, content to follow in his footsteps. . . . Come to think of it, Tom, Walls, and Alec would now be working on the back-shift.

Also at eight o'clock Mrs. Andrew Cunningham was still busy in her kitchen. Soon the children would be in bed. Having put Andrew's supper on the stove, she presently would be free to relax, and await his return. At the moment she was ironing one of his shirts, which was just as well since the one that Cunningham was wearing was to become very, very dirty.

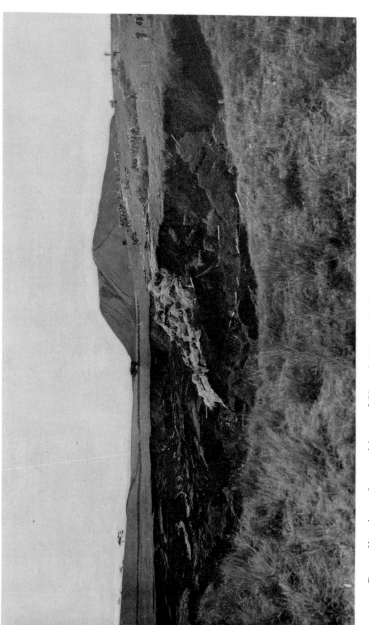

Cascading into the workings of Knockshinnoch Castle Colliery, an underground "lake" of liquid peat has sealed all exits to 113 men. And the thin crust of the field has collapsed on top of it, a black avalanche of death.

2

RACE FOR LIFE

As Andrew Cunningham rushed past a group of startled surface workers, reached the winding-house, and jumped into the cage, his mind filled with the horror of all he had seen in Wilson's field. He argued that the pit was all right. It *must* be. He was still trying to convince himself when he reached the pit bottom.

The noise was what shocked Cunningham, it beat upon him directly he commenced his journey up the road. The cadence was distinct from the rhythm of the pit machinery. Similar yet dissimilar to the uproar he had heard up top; when the field began to slide into the hole. The 700 feet of earth above him— several million tons of it—groaned like an animal in pain. The pit props quivered as though seen through a heat haze.

He plunged into the South Boig. Met, and was astounded by, a man who apparently had no idea of anything being wrong. He was sauntering towards the shaft as though he had all day to spare.

Cunningham screamed: "Get out, you fool, get out!" Although repeated, the words appeared to have no effect save that the miner slowed to a halt.

"Run for the shaft! There's been a fall, I tell you."

The man continued to gape. Cunningham could waste no more time. He raced on, hoping the other had taken in what was said.

Almost sick with fear but determined still to reach the oversman, he encountered John Dalziel farther along the road.

"Big fall, John. Get out!"

The Salvationist turned towards the shaft, paused, then obviously distressed, ran back to his place of work.

"What the hell are *you* doing?" Cunningham cried over his shoulder.

Dalziel bawled back, "It's my jacket, I shouldna' ha' left my jacket . . ."

And he was gone before Cunningham could stop him.

His jacket, his bloody jacket! Cunningham's breath was coming in short, painful gasps. Risking one's neck for a bloody jacket! John must be mad! Raving mad!

"I'm *daft* enough myself," Cunningham thought, exhausted, "stumbling along down here, instead of staying up top. I didn't *have* to do it. Just said I would . . . but at least I'd never return for a bloody jacket."

But hell, it *was not* the jacket, realized Cunningham. What Dalziel was after was the watch in the jacket's pocket—the watch he prized so much—his "presentation" from the Army.

"God help him," Cunningham mumbled as he ran.

Then he heard a noise like the very crack of doom. Horrified, he saw the Sludge coming down from No. 5 like a wave. A wave of thick porridge piled high from floor to roof, advancing at almost unbelievable speed. He boggled at it, shuddered, then turned and fled before it, shouting . . . shouting . . . shouting . . . pausing only briefly in his wild flight because, glancing back, he saw two men. Maybe one of them was Dalziel. Together they dashed into a side working sloping upwards from the road. The next moment the sludge roared past the entrance to their refuge and sealed the two men from sight. Chased by the monstrous wave, half dazed by his experience, Cunningham staggered on towards the pit bottom.

Peat—for thousands of years it had remained quiescent, in a

hollow scooped out of the rock by ravages of the ice-age. Firm at the top, liquid underneath, this peat had lain in the darkness under Wilson's field. A vast sack of fluid; a sort of underground lake. One hundred yards wide, twelve feet deep, its foul-smelling lair was lined by a mud belt, slimy, static, and nauseous. But impotent until, by a series of fatal coincidences, Man had blundered into it—cracked open the base of the prison containing it, thereby unleashing pent-up evil. . . .

A week had elapsed between the time when No. 5 "holed through", and that in which the roof collapsed, freeing the peat.

As they were to say bitterly when counting the dead, the events leading up to the tragedy had developed into a cumulative climax. Hardly any precautionary intervention had been undertaken by "authority".

The water had come through, but no one had worried. The flow had increased, but no one had ordered the place to be dammed up. Eight chocks had been erected against roof collapse, but the men though withdrawn from the face, had still been kept working elsewhere in No. 5. Even when two chocks had been knocked over the men had remained. Even when that surface hole appeared the first reaction had been to fence it off because of the danger to cattle.

Sour, very sour, were to be the reflections of some folk as to how tragedy came upon Knockshinnoch, sentiments shared especially by those who worked underground, as they meditated upon how their own fates also might one day depend on officialdom's ability to foresee trouble—and meet it at least half-way.

But easy as it is to be wise after any event, it is difficult to be wise in advance. Especially when the "event" has not been recognized as being one. Just accepted as one in a series of small incidents. Not "everyday" ones exactly, yet by no means unique. Dreary, not even intolerable—and, *taken on its own,* each harmless.

Who ordered the charge at Balaclava? Who was to blame—
Haig or Lloyd George—for the massacre of Paschendaele?
How many Arthurian legends are based upon fact? Top
People delight in pursuing such matters through the columns
of *The Times*. A similar more poignant fascination is exerted
by Knockshinnoch upon mining circles.

If the development plan—that "paper" one in the colliery
offices—had not been regarded as a "tracing in draft form"
for the guidance of the management, but had been a "real"
plan, "finished in cloth", it would have been sent to the Sub-
Area Planning Engineer and Sub-Production Manager for
signature and approval.

Then the top planners *might* have noticed that the estimated
course of No. 5 heading failed to take into account the fact
that workings usually rise when approaching an upland fault.

Had this omission been sufficiently appreciated, probably it
would have been equally obvious that by September No. 5
would have far less earth cover than anticipated. Then they
might have rechecked the nature of the cover and obtained an
exact picture of the nature of the soil between the heading and
surface.

Again *if*, as a result of this precaution, they had consulted
the geological map (or *if* the manager had possessed a copy) or
if the original "tracing" had portrayed the peat symbols
marked upon that map . . . but the "ifs" in the Knockshinnoch
tragedy were enough to wring men's hearts.

At first it was little more than a whisper in the ears of Walls
Walker. Seconds later it became a menacing rumble, heard
above the throb of his diesel loco and jangle of the string of
tubs behind. He heard the Black Avalanche approach.

Immediately he knew that something was wrong. He did
not guess *how* wrong. The noise baffled him. Normally he was
quick on the uptake, this time he felt confused.

He was driving towards the shaft along the West Mine,

beneath No. 5 heading. Another train, run by James Serrie, was just ahead of him. As the noise increased Walls wondered whether Serrie had heard it, and, if so, what did he make of it? If this were a fall it must be a heck of a big one. Sounded more like a ruddy earthquake!

Scores of times, day in, day out, Walls had performed the same routine. To the bottom with the full tubs; to the loading point with the empties. Turn and turn-about, there and back again. A skilled job, an essential one, but, once you had the knack of it, a shade monotonous. Yet suddenly he found himself leaning wild-eyed out of the cabin. Seeking—he knew not what. Every muscle was tense; every sense alerted to danger.

When the loco rounded the bend he saw, in the swathe of the headlamp, the Thing that threatened him. It was neither liquid nor solid. It was thick and glutinous, coming from the side of the road and oozing across the track.

Instinctively Walls braked. As the train stopped the fringes of the muck reached the engine wheels. He regarded the quivering mass with momentary puzzlement. He wondered what the hell it was. One swift probe with his foot sufficed to enlighten him.

Sludge! It clung to his ankle, dragged at it as though to tear away the boot. He moved to the far side of the cabin, appalled.

"I must drive on, plough through it before it thickens." The plan had to be abandoned almost as soon as it was formed. He must warn his brothers and his mates, tell them the place was flooding, get them out—*if there was still time*!

Walls Walker leaped from the cabin, floundering in the gluey tide until he reached dry coal. He staggered on towards the Turf Slope. By so doing he sacrificed his one chance of escape.

When Cunningham, after his vain attempt to reach the heart of the pit, returned to the shaft, the sludge, punched

down the slope of No. 5 by the law of gravity and brutal thrust
of the fall, seemed to be pursuing him. Like some monster it
had roared through numerous working chambers, completely
blocking them from floor to ceiling. Now the sludge tumbled
shaftwards at a rate that made Cunningham want to grab the
cage, signal them to haul him up, abandoning everything in a
desperate bid for personal safety. He had done his duty and
more. He could not get through the sludge, no man could.
It would take an army of engineers with full equipment. Even
they would make little impression upon the ever thickening
curtain, dropped between the escape route and the trapped.
Why should he stay?

"Because I *must*," he thought.

There were still one or two things he could do to help. His
conscious would not allow him to omit them. To start, he could
telephone a report of the set-up to the manager.

Halliday's answering voice was sharp-edged, determined.

"I'm coming down," he said.

Cunningham's smile, as he replaced the receiver, was wry.
"Well," he reflected, "it'll be nice to have company."

On Halliday's instructions his next move was to try to tele-
phone the firemen in charge of the sections. Order their with-
drawal towards the main shaft. Should this prove impractic-
able, towards the winding-shaft of Knockshinnock No. 1, lying
a quarter of a mile to the north, this provided the only other
means of exit.

Try though Cunningham might, it was impossible to rouse
the "districts". Some already had been overwhelmed, in others
the telephone lines were down. Already it was too late for men
to fall back upon the cages. The sludge barring Cunningham's
inward journey from the main shaft had tributaries flowing
across the escape route to No. 1.

Sixty thousand tons of peat, stone, and mud were working
through the underground labyrinth. Routine measures for
coping with underground emergencies were useless. There was

no argument. The monstrous force was irresistible. Almost beside himself with frustration, Cunningham thought of the lives at stake, and to his surprise, found himself attempting to hit back.

Opening at right angles to the sloping road to the pit-bottom along which he had run was a side heading. Half-way up, he remembered, was a steel trap-door, leading to a series of disused workings far beneath the level of the existing mine. Dare he go back? Dare he enter the heading? Suppose he could reach the door and manage to open it. Might not the course of the sludge be diverted? Might it not drain into the empty depths below?

Of course the idea was crazy! Near-suicidial when considered from the angle of personal safety. Though moving more slowly now, the sludge was only a few yards from the heading entrance. All too clearly he could visualize what an attempt to reach the door might mean. Quick in . . . quick out . . . or else God help you, Andy! Should he delay too long after entering he would be trapped, cut off from the main road, flounder, choke and die. Like a fly in the bloody soup.

Andrew Cunningham had never thought of himself in the guise of a hero. When he had heard brave tales about the war he had listened admiringly enough. His own reflections had run this way: "They can have that lark if they like it—but it's not the lark for me!"

As he ran back the way he had come, he did not feel particularly courageous. "It's just that you *cannot* do it . . . *not* try it . . . you just have to take a chance!"

He reached the heading, to be almost paralysed with fright. Sensitive despite his verbal reticences, he saw the scene with appalled clarity. The sludge "slam shut" behind Dalziel (or the man he took for him) and his mate. Soon that damned sludge might seal off Cunningham too. Still he pressed on . . . a slight, lonely figure fighting down fear.

Even when he reached the door, grappled with it, cursing

its failure immediately to respond, he experienced none of the self-satisfied glow he had always imagined the reward of heroes. Quite the reverse! As his slim fingers slid over the coal-encrusted steel his dominant impressions were of wonderment, fright and sorrow. He was so depressed that almost he could have wept. He was sorry for himself, for Margaret, for his children. Sorry for their sakes that he ever should have been involved. He could not begin to understand his own thankless, lunatic gesture.

Still he *did* open the door ... And then had to shut it again! For the sludge had already reached there from other workings and was rising rapidly. There was a danger too that the pit's ventilation would be upset.

On his way out he again met the sludge. He just had not been sufficiently fast. Its outer waves were pouring into the heading. He must fight his passage—or die.

At a point near the road's entrance he plunged waist-deep in muck. He staggered, fell back, clutching at the steel girders that hooped over the haulage way, to brace himself against the pull of the current. Arms above his head, fingers grasping the roof supports, he pushed his way through, the sludge continuing to suck at him, clogging his boots, dragging at his clothes. Hand over hand he levered himself forward, until, almost unbelievingly, he was ahead of the sludge, running towards the shaft. He had staked his life without having had to sacrifice it. He was safe—for the moment,

During the few days in which, after near obscurity, Knockshinnoch became the focus of world interest, ousting even Korea from the headlines, it stood as a symbol of men's fortitude and valour.

Although responsibility for the disaster might stem from weakness in the chain of high command, the behaviour of the "troops" was for the most part exemplary.

Thus, when Walls Walker jumped from his loco and ran

towards the Turf Slope to warn his section, like Cunningham, he had no desire to be a hero. He was appalled by the menace of the inflow. Almost involuntarily, however, he risked his life and young family's future, for the sake of communal loyalty.

Scarcely had he jumped from the cabin than the main stream of sludge collapsed upon the roadway. Crashing into the seven-ton engine it hurled it from the rails, bouncing it like a pebble flung by the tide. Grasping the steel tubs—each weighing five cwt., plus three times this weight in coal—the invading force toppled and finally concertinaed the train. Sludge now threatened the roof and wall supports; ripped them free and carried them forward on a surging crest. This spread right and left along the track, barring retreat to the shaft.

Still Walls Walker did not regret his missed chance. Least of all did he feel heroic. At that moment of catastrophe he had no thought for anything save to warn the others, impress upon them that, if they did not quit their work places, they would be dead men. All in less time than it took to smoke a cigarette.

Stumbling as he ran, to the roar of the sludge and of his own blood pounding through his brain, he saw the black walls of the side road sway tipsily past his helmet. Desperate, confused, he could not smell coal for the sweat.

"Sludge!" When he saw the lights ahead he could not wait to join them. He shouted again.

"Sludge! It's sweeping the track. There's been a fall, a hell of a fall!" He seemed to himself to be screaming the words, but the gang near the Turf Slope took not a blind bit of notice.

"Sludge!" He was almost on top of them before their unconcern changed to action.

One grabbed him steadyingly by the shoulder: "What the hell's gone wrong with you? What the hell are you trying to say, man?"

Only then did Walls realize that he had not been screaming at all. He had no power in his lungs. His tongue was like

brittle wood. He was so breathless that he could scarcely swallow. Again he tried to tell them. This time he spoke stiltedly, moving his wooden-seeming mouth painstakingly.

"There's been a fall. There's sludge across the track. We must warn the others."

At last it registered. One miner ran to spread the news and alert the main body of the men. Walls sagged exhausted against the coal.

"That was *fine* of you."

Dimly he was aware of M'Latchie addressing him.

"What else was I to do?"

His voice sounded flat. For the first time he had a moment for thought. The desire for self-preservation clutched at him. Wife . . . children . . . baby expected next week . . . He realized it all with shocked concern . . . the thought of those dependent upon him at home.

"Come on," he shouted, with returning strength. "High time we began to see if there's still a way out."

Andrew Houston was nobody's fool. His first dazzling pay increase, sixpence a day, had been earned when, seeing the value of specialization, he became a pony driver. He had never looked back since. Not conservative in his approach to coal-gathering Houston kept pace with every modern technique. Joy-loaders, coal-cutters, conveyors . . . he thought them equally wonderful. But there were certain old-fashioned maxims he considered to hold good for the pitman, whatever the technical changes. A miner's reflexes to events outside "routine" must be speedy, almost automatic. His life might depend upon them. . . . A person in charge must have even smarter reactions. To Houston an oversman always must be "boss". Commanding respect, he must assert authority at pressing moments of crisis, accept responsibilities outside the formal mandate of rank.

Thus after his "run like hell" command to Montgomery and

Haddow as the conveyor lurched towards them Houston acted with confidence and decision. Another man might have ordered a rush towards the shaft, which move would have proved disastrous. Houston had other plans. He sensed that the flood was outflanking them. Cascading through the workings which sloped down from No. 5, it would split up into twenty separate tributaries; rage towards the pit-bottom and sever their escape route. Houston refused to be bluffed by a too obvious retreat. Equally by instinct he made for the Garrowscairn Section, innermost point of the colliery.

"Once there, we'll make for the West Mine station," he panted to his companions as they ran.

"The station? That's a hell of a way from the cages."

"Yes, and from whatever's happening here. Now hurry!"

Houston had another reason for his choice. Though apparently isolated, its back to the "wall" of unbroken earth that pressed upon the frontiers of Knockshinnoch, the station had access to other colliery sections. These included the road network leading to the escape shaft of the old Knockshinnoch No. 1. Furthermore, there was a telephone....

" With luck," Houston brooded, scrambling unerringly through the black maze of the workings, "we'll be able to use that phone . . . recall the men—those who survive—rally them. Given time to think and an enormous amount of luck, maybe we'll find a way out."

Luck? An enormous amount of it? . . . the oversman shrugged off his grim misgivings. The immediate necessity was to reach the telephone . . . use it to alert the others. There would be men at the station. . . . He could use them as messengers if the phone had failed. Houston quickened his pace, considering the issues involved. Bloody fine it would look if there were only three survivors—and the fellow in charge one of them! When they reached the Garrowscairn he was winded and in a muck sweat.

"Getting old", he thought, blinking round at the others. He

could hardly see their faces through the darkness and the sheen of the moisture before his exhausted eyes. He was almost glad. He sensed that they were groggy too. Their breath was damned short—almost as short as his own. He could hear them wheezing.

"Best rest for a minute," he advised, "then join me at the station. We'll meet at the telephone."

In her home at Connel Park young Jessie, wife of Walls Walker, was busy knitting. Her father lay ill with pleurisy. Her uncle was visiting him. She was listening, part to their conversation, part to the wild noises of the night. She was depressed, unlike her usual self, haunted by vague feelings of disaster. She thought, "Maybe it's because of the bairn."

Some mothers had all sorts of miserable fancies, she had heard. "But *this*," she reflected sadly, "should be a time of joy."

Jessie shivered slightly, put away her knitting . . . she would be glad when Walls got home.

No premonition of trouble disturbed the domestic peace of Mrs. Andrew Cunningham. Having put up her husband's shirt to air, she took a spoon from the kitchen drawer, lifted the lid of one of the saucepans simmering on the stove and stirred the supper. She glanced at the clock : Andy would be home soon. The broth was ready. All she now had to do was to salt the potatoes and finish laying the table. Mrs. Cunningham hummed to herself as she put away the iron and took out the tablecloth.

"Withdraw your men. Bring them to the phone in the West Mine." The warning sent out to the firemen in charge of the sections, Houston wiped his filthy brow, steadied himself against the wall and endeavoured to think.

On one side the tunnel sloped away to the pit-bottom, half a mile distant. On the other, west of the telephone and invisible

in the darkness, was the face; terminal of Knockshinnoch's far-stretching advance. The timber-laced walls of the West Mine were twelve feet apart. The centre of the rough-carved roof hung in a dark curve ten feet above the loco track, patchily visible in the glow of a pit lamp. Heavy, hurried footfalls of the messengers died away. The oversman's elation at there being time to warn the men died with them.

The noise worried him. The continual grumbling thunder from the east. The fall, or flood—he was unsure how to define it—must be greater than he had at first suspected. The mother and father of all other mining mishaps, to judge by its echoes. The thing had started in No. 5 but by now its violence had set the entire colliery atremble.

No. 5 . . . his brother James had been working there. What hope for James, at the centre of the catastrophe? As Houston stood by the telephone he found it almost impossible to smother that sudden fear for James. However, for the sake of duty, it must be done. Duty to other people's brothers. His charge and responsibility. Grimly he forced himself to consider the overall position again. It was not reassuring.

In the latter stages of his journey through the Garrowscairn he had begun to realize that the alternative escape to the main Castle shaft—the road to the old shaft at Knockshinnoch No. 1 —would be blocked by the inflow's unprecedented force. Earlier, with his guiding knowledge of the layout of the colliery, he had ruled out hope of exit via the South Boig. Now he grew perturbed over the route through the West Mine. Suppose the sludge had poured down from No. 5, entering the tunnel at its lower end? At the station they were on rising ground. They *might* remain immune from direct attack of the flow, but the sludge at the lower end might bar their last chance of escape. What happened then? He peered bleakly into the blackness down the slope. Found no encouraging answer.

"Hell, man," he told himself, suddenly angry at his fears,

"high time for action. *Do* something! You're becoming a regular old woman!"

Abruptly Andrew Houston decided to take a walk to see exactly how far he could go towards the pit-bottom. Men recalled from the working sections would take a few minutes arriving at the station. Meanwhile he could wander down the track and judge the condition of the route.

As he trudged on the thunder of the fall grew increasingly loud. Alone with only his helmet light for guide he found the atmosphere uncannily depressing. He had known Knockshinnoch for six and a half years. Give him ten shillings for every trip he had made along the West Mine and he would be rich. The once familiar route now seemed alien, charged with evil. The blackness of the pit weighed heavily upon him, he felt short of air. The whole time he was torn by separate fears— anxiety for himself and for the men he led, anxiety for his brother James. This melancholy sense of solitude grew so intense that it was a shock to recognize the glow of lights ahead.

One belonging to the loco-driver, Walls Walker; the other to M'Latchie. Walls spoke first.

"If you're thinking we'll get out by the West Mine, you can save yourself the bother. Farther on the road is blocked from pavement to ceiling with sludge."

There was a heavy pause.

"No," interpolated M'Latchie sombrely, "we'll no' get out this way!"

In the mechanization section the steel arms of the cutters were tearing the coal from the face, tumbling it over to the massive joy-loaders to pass on to the shuttle cars journeying to the shaft.

Seven men, Tom Walker among them, were working the section. They were a fair distance from No. 5, at first unaware anything was wrong. The machinery made so much noise of its own that even the thunder of the fall came to them only as an

off-stage whisper. They thought that the stint was progressing nicely . . . until the lights went out!

Someone swore, loudly.

"A bloody fault,' exclaimed another.

A few moments of indecision and they grouped together in the dark.

"What the hell's that . . .?" Men in workings nearer No. 5 could hear it quite loudly: it seemed to pulse through the blackness.

Someone said: "Sounds like the sea. . . . You know, the way you hear it when you're inside a cave. . . ."

Troubled, they listened to the gathering roar. A voice said, "You're right—with the tide coming in!"

Still the truth did not register. They continued speculating until a messenger arrived with Houston's message.

"Withdraw to the West Mine station."

Although immediately complying, a few of the team were puzzled by the oversman's reactions. They seemed extreme.

Elsewhere in the colliery everything was sacrificed for speed. A boy sent to alert burly Dave Jess and his mates screamed the warning. They had heard and had been alarmed by the echoes of the fall. They were nearer to it than the men of the mechanization section. No urging was needed to make them go. Only the stone-deaf could be oblivious to the clamour . . . the shouts of the boy, the breaking of the earth.

Some twenty minutes later Jess realized he had left his tools behind. The offence seemed almost unforgivable. No good miner lightly abandoned his tools . . . so why the Hell? Shovel, mash and saw . . . they were not mere pieces of personal equipment, they were symbolic of his loyalty to his calling and himself. Well-cared for, scrupulously clean, those tools were precious, as the black bag to the doctor.

"Why the devil did I do a thing like *that*?" Jess mumbled, hoping no one had noticed. Looking round sheepishly at the others he saw that they also were without their gear. Each

man had broken the habit of a lifetime. Such is the power of tradition that they now marvelled at this forgetfulness.

More men came stumbling into the station refuge. Jess said to one of them : "Do you know what is happening? Can't be a normal fall . . ."

"There's been talk of peat," was the reply.

"Peat! Don't be so daft . . . not seven hundred feet below, man. You don't get peat seven hundred feet below!"

"Grow a few more years, laddie, and you won't be talking like that . . . I'm turned sixty now and I'm surprised at nothing!"

"I'm coming down myself." Those were Halliday's words. He joined the weary, sludge-drenched Cunningham. They must try again to find a way through the slimy barriers separating them from survivors in the shafts. Both manager and conveyor-shifter knew they were taking an outsize risk. The peat—ubiquitous and irresistible—was still advancing, still expanding, still flowing down towards the pit-bottom. They probed up the return airway. The inflow threatened to cut off their escape line. They had no better luck testing a different route. Each fresh effort had an accompanying sound of further falls as more and more of the field above was dragged into the pull of the whirlpool, more and more waterlogged peat rolled into the pit. Still they persevered. Hopes decreased every uneasy minute.

The agent, Bone, reappeared. Like Halliday he had not been content to stop on the surface. He wanted to see personally how things fared. Just as the others descending in the cage to help had been appalled, Bone found that, if anything, the situation was worse than anything he imagined.

Horrible thoughts came into the minds of the volunteers below. In vain they strove to outflank Knockshinnoch's enemy. Had most of the men been overwhelmed by the first fall? At this very moment was death approaching the survivors? The

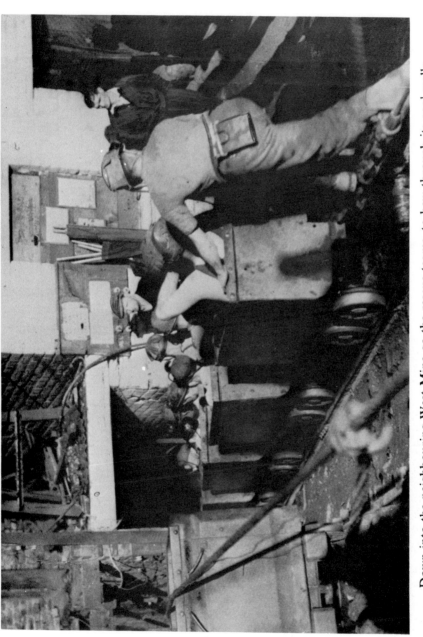

Down into the neighbouring West Mine go the rescue teams, to hew through its coal walls in a bid to reach the trapped men.

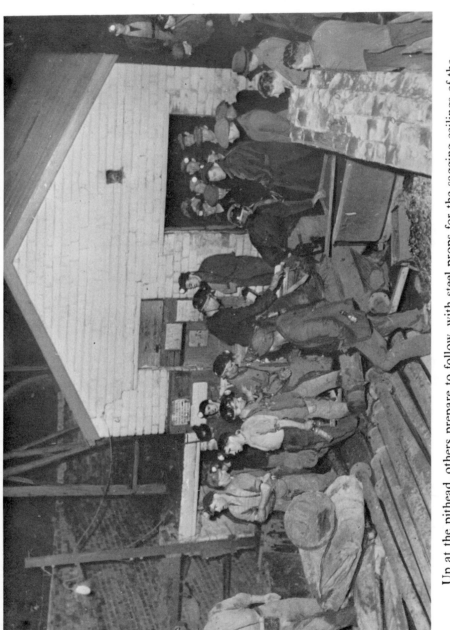

Up at the pithead, others prepare to follow, with steel props for the sagging ceilings of the treacherous rescue-route.

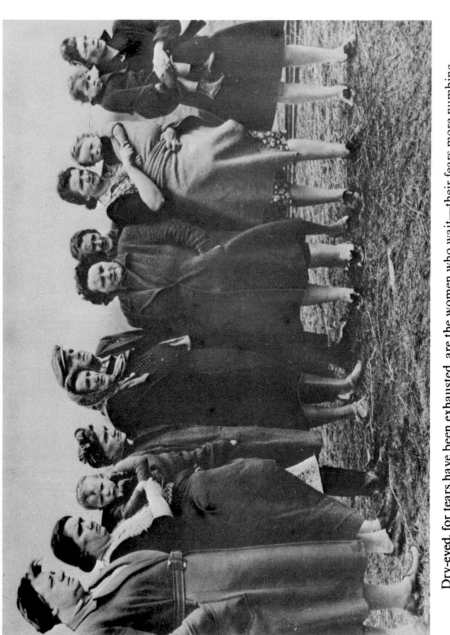

Dry-eyed, for tears have been exhausted, are the women who wait—their fears more numbing than the bleak Ayrshire wind.

sludge-barrier had broadened considerably. It must be hundreds of feet wide. And it was so high. A moving monumental mass of muck. Impossible to think that air could break through it from above.

Up top, a telephonist grimly trying to summon aid logged as follows : "8.40—Nobody at rescue station."

"God !" exclaimed an anxiously-listening miner. "Will *anything* ever go right ?"

New Cumnock appeared to be gripped in the usual nightly hush when Pup Walker returned from the Dalmellington meeting. Bars were shut. The straggling street was clear. The big hotels in the neighbouring beauty spots to the south still had an hour for dancing. But here, as befitted a working community, early hours were kept. Pup did notice a few exceptions to the general gloom. Lighted windows of the homes of men on the back-shift. Wives were cooking the late meal and awaiting their husbands' return.

Rather damp, Pup reached his own front door. His was a small house where Mary and he had lived since their marriage thirty years earlier. Not for the first time he thought that though Dalmellington was not a world away, nevertheless he was glad to be home. Every time Pup came to his house, however short his absence, he felt the same pleasure as a returning exile. A glow cosy as the welcoming kitchen. Six sons, three daughters . . . all reared within these friendly, familiar walls.

Mary turned from the stove. "A fly cup, Dad ? The kettle's just on the boil."

He eased off his boots and sat in his favourite chair. "Aye, I'd like that . . . you're a clever woman to guess it."

He listened to the rain, glad he was out of it. Glanced at the firelight, flickering on the china. Pup's sense of well-being increased. He had known hard and hungry times, but now he was content.

"Is Alec not back yet from the pit ?"

The question was casual, drowsily uttered. Pup was not really surprised their youngest was absent.

"Overtime again, I expect," Mary said, echoing his thoughts. "Been doing quite a bit of it just lately."

Pup nodded, faintly amused. Alec was keen on the money. Worked hard for it, too. A lad saving for a rainy day, or maybe to marry. Not that one really knew with Alec. The boy did not tell one much. He would be all right if he did as well as the others. Take Tom and Walls, now, who would be with Alec on the back-shift. Tom, their tall eldest, had a charming English wife. And Walls . . . "But how's Jessie keeping?"

A flicker of concern passed over Mary's smooth, round face.

"Oh, not quite so good today. Just a wee bit depressed. I'll be glad when it's this time next week and we've had the bairn arrive."

"No more glad than she and Walls, I'll bet."

Pup passed his cup over for a refill.

3

CUL DE SAC

"You'll no' get out this way."

The words re-echoed in Houston's ears. Struck chords of panic in his brain. For a moment all he could do was stand there, stiff as a pit prop, and about as silent.

"It's blocked from pavement to ceiling . . ."

Blank-eyed he stared at M'Latchie and Walls Walker, only half believing them. Then transferred his gaze to the darkness of the roadway sloping down towards the shaft. No way out to the pit-bottom by the West Mine! No way out either to the old Knockshinnoch No. 1. And no way out, as he damn' well knew for himself, by way of the South Boig.

During that pause the workings seemed to spread before him in a dreadful panorama. The vision horrified. He wished to God that he did not know so much about the place. That he was still sufficiently blind to continue to hope. A pit boy might have been fooled; still think that threaded through these catacombs must be at least one safety route. But there was no fooling Andrew Houston. He could see it all—the tragedy and its probable sequel.

He managed to sound cool as, shrugging, he turned again to his two companions. "You'd best come with me to the telephone. We'll think about it there."

Think about it? What a hell of a thing to think about! And what good could *thinking* do! They could think about it until they lost the power to think at all . . . think until Doomsday.

His limbs were like lead as he went back the way he had come, Walls and M'Latchie with him. They reached the westernmost end of the West Mine.

Houston said : "Up at the station we should be able to keep our feet dry. I don't think the sludge will reach that far."

Inwardly he reflected. "Aye, and we'll be a good mile from the shafts. Sealed off from them by God knows how many thousand tons of muck and displaced coal. It'll take months to clear the stuff."

Houston's drooping lower lip steadied. He stiffened his long backbone. Hell, he was the oversman, the fellow in charge down here. It was his task to conceal his fears. He must not brood : he dare not. Brooding might cause the mask of calm to drop from him. He must set an example to the men who, for better now or worse, were his responsibility.

If they *had* to die they might as well "die decent"!

Pit Disaster!

For the operators on duty at the pocket-size local telephone exchange it was to be a night of non-stop devoted labour. Rescue brigades had to be alerted, doctors roused, police informed. As the news reached NCB officials, Union organizers, and the Divisional Board in Edinburgh, there came a flood of incoming calls, from seekers of information. Soon the lines were loaded with the business of disaster. Astonishingly, however, the little town of New Cumnock remained relatively unaware of the drama upon its very doorstep.

"Don't panic relatives," had been the plea from the authorities. So far this appeal had been respected. New Cumnock would know soon enough without any indiscretion on the part of hard-pressed operators. New Cumnock would know of its crisis the moment the men of the back-shift failed to return home. Many a meal would go untasted; many a tear shed before morning. . . .

Meanwhile Bone and Halliday emerged from the pit to

explain matters to Stewart, the Sub-Area Manager. The situation was outlined as they knew it. They did *not* know what was most important point of all, the point everyone ached to have clarified. How were the men? . . . Alive or dead? Had they a fighting chance? . . . Or were they sealed in a gas-laden tomb? At the pithead the anxious questioners, growing more numerous, tried to read the faces of the officials. It was no use.

For *they* don't know. They've no idea at all!" said a surface worker bitterly. "They're ignorant as the rest of us. All they can do is hope!"

Just then, quite uncannily, the phone bell rang. *The telephone from the workings below.*

Andrew Houston spoke. *It was like hearing a voice from the grave!*

"Good God!" one of the men cried. "But who could have known it?"

"The chap you've just named," replied his mate gravely.

The pit telephone was prosaic enough. Squat in outline, battery-powered, connected from the pit-bottom to the surface by a mile of slim cable, taut-stretched now by the pressure of the sludge. To Houston, the Walker brothers, and all the others mustered around the instrument, it had been transformed into a kind of miracle.

Houston's call to the surface had been just routine action. Typical of his determination to run to form: keep things "tidy". In the name of all that made sense he had never expected the instrument still to be working. The phone lines passed through the lower end of the West Mine before climbing the sides of the shaft. The place was choked with debris and sludge. How could he hope so vulnerable a link should survive the cataclysm? Yet it had.

"It's not natural!" Fireman Capstick protested, summing up the general mood of stupefaction. "It's against all the laws

of reason, every blasted one of them. I still can't believe it. The whole thing's bloody impossible!"

Impossible? That was how they all felt about it. Still, there was no denying the telephone's efficiency. As Houston reported their present plight to the management even the brooding darkness seemed less fearful. No longer did they feel so alone. They were in contact again with the world of living men. Friends who would fight for their safety.

The very sight of the phone had brought a lump to the throat of Walls Walker. The significance of the thing almost overwhelmed him. Up top, that was where the line led! Into the freshness; out of this present nightmare . . . over to Jessie and the baby-to-be . . . to everything he wanted. As abruptly his comfort disappeared. He was beset by a fresh worry. What the hell difference could a telephone make to *this,* their pressing physical plight? It could not dig through the dirt, or bring them air to breathe! A phone only could provide them with useless words. No good—no bloody good at all. They were trapped like rats. If anything, the phone aggravated their agony.

Though sorry for himself, young Walls felt even sorrier for Jessie. That telephone . . . that blasted telephone . . . every stage of their sufferings would be reported by it. Better by far without it.

"For surely," he thought, "it would have been kinder for them at home to picture us having died quickly in the first onrush. It will torture them to think of us still here, weeded out one by one; impossible to save. Might as well face facts. That will be the way of it."

His mood swung back again to fair as Tom arrived at the rallying point. Walls had been worrying about his brother. God, it was good to see him!

"Misery likes company." He *had* to wisecrack to cover his soft feelings.

Tom Walker grinned back. "In that case we'd best go search for Alec. I hear he's around, and okay."

"But *how?* My God, *how* did it happen?"

The voice belonged to the father of one of the back-shift men. The question was echoed by thousands before the night was out.

Geological symbols "overlooked". One hundred feet of "cover", proved as thirty-eight. A field drainage system helping to solidify the surface of the peat lake, disguising it. Knock-shinnoch was bedevilled by coincidence.

Since 1940, machinery had probed deeply beneath the surface of Wilson's field on three separate occasions. Neither the drill proving the existence of the productive seams, the borer preparing the way for a ventilation drift, nor the mechanical digger used to lay a pipe-line to the pit baths, had encountered anything save "safe" stratas of rock, coal and sandstone.

If only everyone had not been so aware of this negative response. Or the digger had worked just 150 yards farther west. Even if the officials had chatted with Farmer Wilson, asking why he did not cultivate apparently fertile soil. Just one of those "ifs" and No. 5 might have discontinued its steep climb towards disaster. Knockshinnoch, so the superstitious said later, seemed predestined for disaster.

When the face of the heading "holed" that fateful morning of August 30th "gravel" was revealed by Strachan's shot. That gravel was a fraud. Camouflage, a trap; for above it was mud, and above that, the peat.

Then there was the clear, pure water, draining through the bed of sand and gravel. The water's very innocence helped to spring the trap, lulling the victims into false security.

Finally there was the weather. The wettest September in memory. Rain would have mattered less had it struck a month earlier, when the heading was far from the surface, snug and safe below.

"But *now*? My God, *now* . . ."

The increased flow of the water, reckoned the experts later, had dislodged the dirt beneath the chocks. The fall from the roof which followed weakened the thin layer of rock and coal at the face. The fraudulent sand and gravel then cracked. The mud above cracked with it. As the liquid peat raced into the heading, the unsupported surface of the field sank likewise, sucked down as if into a waste pipe.

To the men who had reached the West Mine the *how* did not much matter. Not on the night of September 7th, immediate aftermath of the tragedy's occurrence.

All *they* were concerned with was the job of keeping alive.

"Time now," said Houston, "to see who's here and who isn't. Get a list of those missing. . . ."

He called the firemen to report upon the strength of their teams. Two of the five firemen were absent.

"Where's Strachan?" Houston was outwardly calm as he asked the question, but inwardly tormented. Strachan had been in charge of No. 5, where James worked.

No one had seen Strachan.

"Any of his section here?"

Again no answer.

"Where's Archie Crate?" Houston's voice sharpened. He was throttling back personal worry. "I thought Crate was said to be O.K.?"

A couple of miners spoke from the fringe of the crowd.

"Crate and his men are trying for an escape route through the South Boig. They've gone by the return airway. . . ."

Damn! *That* meant the team had gone back the way he had come . . . the route he had led Montgomery and Haddow to safety before exploring the West Mine towards the shaft. Roof falls were more frequent. The sludge was so widespread that they might be in trouble. There was no alternative. He must go and look for them.

Houston was intensely relieved when, acutely aware of the hazards to the section, he saw ahead of him a bobbing file of lights.

"Couldn't get through," said Crate sourly, bringing his section in.

"I could have told you that."

"Bit of a bloody mess isn't it?"

"Bloody," answered Houston.

They returned to the West Mine and he conducted another check-up. No one was missing from the sections he had warned. The surface told him that some of the pit-bottom men also were safe. The latter had been tipped off by James Serrie, driver of the train progressing along the West Mine in front of Walls Walker, Serrie had been on the shaft side of the sludge when it poured over the track. Now he had joined the survivors at the top.

Still no news of No. 5.

"An inrush has taken place at Knockshinnoch Castle . . ." At 9.40 p.m. elderly but active Alexander Baillie MacDonald, Area Production Manager for Ayr and Dumfries, received the news.

"It's serious," said his informant. "Not all the back-shift men are out."

The phrase was a masterpiece of understatement. Not until an hour later when MacDonald reached the pit after alerting other officials, did he realize the full extent of the disaster.

He met Stewart, Bone and Halliday. The latter was so changed in appearance that the APM was shocked. Lined in face, clothing plastered with sludge, the manager looked like the weary ghost of his usual spruce self.

"One hundred and twenty-nine men are down there. No escape route is open. Both No. One and the Castle shafts are blocked."

"Lord!" murmured MacDonald. It sounded like a prayer.

"I've been down and tried to make contact," Halliday explained, "but it's impossible . . . you can't imagine what it's like!"

"But . . . can't we shift the stuff? Can't we carve a way through?"

Halliday shook his head. Descending the main shaft his men had tried to clear part of the sludge by loading it into hutches, and bringing it to the surface in the cages. The magnitude of the fall mocked their labours. The task was as hopeless as King Canute's attempt to turn back the sea. Soon the inflow lapped hungrily against the shaft itself.

All the while the hole in the field widened. It was already estimated by a worker, who had known war-time London, as far larger than the crater near his home produced by an exploding V.2.

The quartet of officials re-examined the plan of the workings. It brought small comfort.

Suddenly someone said breathlessly, "They're on the phone again. The sludge is moving inbye along the west level towards the men. . . ."

Young Mrs. Walker had come to the end of her very trying day. Her uncle had just left. She was clearing the crockery. She glanced at the clock—twenty minutes to eleven. Walls would soon be home. Thank goodness for that, she thought.

The earlier depression which she had tried to shake off had, if anything, deepened over the past hour. She could not rid herself of a sense of foreboding. She had tried telling herself it was a stupid fancy, or the fault of "George", her son-to-be. Her arguments failed to convince.

"I'll be glad when Walls is home. Everything will be all right, when Walls gets home."

A knock on the door panicked young Mrs. Walker. There was her uncle's voice again. He could not have missed the bus. He had not left anything behind. That could only mean—bad

news. She was absolutely sure of this. Her formless fear crystallized into reality.

"What is it? What has gone wrong?" She was trembling as she faced him in the passage.

"Now, Jessie, don't be alarmed."

Her face drained of colour: "Is it Walls?"

He took her by the arm. "You're not to fret, but there's been a bit of trouble at the pit . . ."

Jessie sat down. "You'd best tell me the truth. . . ."

She spent the rest of the night awake and dressed, listening to the sound of the rain, the hissing of the kettle, kept on the boil for Walls. And the loud ticking of the clock. The minutes themselves seemed to move very slowly as she waited . . . and waited . . . and waited . . .

Houston replaced the phone. Feet astride, he faced the men crowding around him in an anxious, inquisitive semicircle. He felt extremely warm and half-mechanically wondered if this were due to his exertions or to the fact that the pit's ventilation was going haywire. Such a thought was disturbing; he thrust it from him. Time to worry about the complications later. The main thing now was to try and maintain morale. He glanced at his fellow victims: 115 of them. Some were mere youngsters —like Alec Walker and Gibb McAughtrie, the Bevin Boy. Others, such as James Haddow and Tom Currie, were men in their sixties who had been in mining since the beginning of the century. No use trying to fool such veterans. Houston did not try. Bluntly he told them: "We are closed in. All the normal ways of escape are stopped."

The news was received in silence, complete save for the distant sullen grumbling of the sludge.

"On the other hand," he went on, "we've been extremely lucky . . . thanks to the phone they know all about us on the surface and will move heaven and earth to free us."

"They'll bloody well need to," someone mumbled.

"Shut up," they shouted at him. "Let's hear the oversman."

Houston was no speech-maker, which maybe was as well. Fine phrases would have been howled down by the tense, taut men. Restoration of self-confidence was what was needed. This he somehow effected.

He told the survivors that he would hide nothing from them —neither good news nor bad. He again reminded them that the whole country would be working for their rescue. He restressed that much would depend upon their own behaviour.

"We might be here for days. So you'd better make yourselves comfortable. . . ."

There was a grim laugh or two at the word. This encouraged him to pretend his choice of it had been deliberate.

"Meanwhile all but a few lights must be turned off. We must conserve the batteries against the time they're needed."

"Well," he reflected, having come to the end of his speech, "thank God *that's* over. Thank God, too, that they've taken it all so well."

The following discussion was brief and practical. Sam Capstick, self-reliant and determined shotfirer, argued: "I still think there might be a chance—only a bare chance, mind—of wriggling through to the South Boig section."

Houston hesitated before giving him permission to try. Convinced that the attempt must fail, it nevertheless might be best that Capstick's energy found an outlet. There was always the slim hope that some of the missing men might have escaped the initial onrush. Should this be so, the exploring party might have a chance of finding them.

"Okay, Sam. If you think it's worth it."

Capstick and his six volunteers worked hard. They were away for over an hour before confirming Houston's fears. The sludge had advanced still farther: there was no sign of human life. Wearily, dejectedly, they announced the news, before slumping down among the rest of the men; huddling together

in the shadows of the pavement, resting their helmeted heads against the jet-black walls.

"You know," Capstick said to Houston quietly, "I don't think there's a chance in hell of them being able to get through to us. The stuff has spread out so that there must be half a mile of it between us and the shaft. Worse, it's so damn' gluey! The rescue brigades would be like flies rolled up in a fly-paper."

Houston nodded, since the fireman's sombre opinion agreed with his own. Behind them, the sludge; ahead, the coal. They were caught in a cul de sac. The two agreed, however, there was no sense in broadcasting such fears.

Dutifully Houston phoned the surface once again, keeping his voice low. "There's no way out of here and no way you can approach us from the east. The only alternative is Bank No. 6."

And a hell of a fine alternative *that* is, he thought.

4

THE BARRIER

"THERE's no help for it otherwise," said Bone. Houston's grim conclusions about the impossibility of escape via Knockshinnoch had been echoed by anxious men up top. So had his none-too-optimistic suggestion of an approach from the Bank Mine. His reports, together with Halliday's and Cunningham's impressions, enabled officials to plot the sludge progress. They calculated its probable limits. Few illusions remained.

"I tell you," Bone repeated, "there's no hope at all of reaching them from the shafts. We've just *got* to try from the west—try to crack through from Bank."

Bank No. 6 lay a mile south-west of Knockshinnoch Castle's winding shaft. A drift mine, access to the coal being obtained by way of a steeply sloping road which dipped into the earth for nearly a thousand yards. This main roadway from the mine mouth branched into several subsidiary roads and workings. Some had been driven towards Knockshinnoch.

"But I still don't see it," objected one of the planners, ". . . I don't see it at all. The damn' roads don't stretch that far. They stop far short of the Castle."

"Nearest they go is the Waterhead," argued a colleague. "Even then it'd take a month of Sundays to get through."

The general gloom seemed justified. Everyone present was acquainted with the Waterhead area. Knockshinnoch Castle and Bank No. 6 had sent long feelers into its rich main-coal.

The limit of exploitation for Bank was represented by a worked-out, long-abandoned road, degenerated into a derelict, water-logged tunnel. Running parallel was the Castle's effort—the long slim finger of the Waterhead Dook. Separating the two was a massive barrier: an untapped area of rock, earth, and coal. Nearly two hundred feet wide, it was impossible to breach.

"Except at one point," Bone interrupted quietly, ". . . *the place we made the Borehole.*"

Years earlier, men had been withdrawn from the pencil-straight galleries. Once trim timbers had been left to rot. The pulse of the south-eastern sectors of Bank No. 6 had ceased to beat.

Then it was that a working party from Bank's prosperous neighbour commenced a clever, uncomplicated operation to improve the Castle's drainage. "Wet" Knockshinnoch Castle accumulated much surplus water. Bank No. 6's disused workings, now dark, silent catacombs, might be receptacles. They lay at a lower level. Could not a way of draining the surplus water into them be found?

From the Castle inched a brand new road. Though primitive and narrow, it progressed to within twenty-four feet of the nearest Bank tunnel. They then drove the borehole through the remaining barrier.

"It was a simple plan, but really quite effective," Bone added thoughtfully, his history-lesson delivered. "With luck, and a hell of a lot of hard work, it even might offer Houston's men a break!"

No one spoke for the next few seconds. Each saw the same picture; compelling, unbelievably sombre. First, the narrow black tunnel leading from the West Mine station to the Dook. Next the narrow black tunnel constituting the Dook itself. Even narrower and blacker, the drainage tunnel forming the

road to the barrier. Silence. Darkness. The reek of sour water and coal.

MacDonald looked briskly at the pit-plan.

"You're right about one thing," he agreed. "There's no hope otherwise. . . ."

As if to underline his words, a moment later the conference learned that the pit-bottom sludge had moved forward. It had flopped into the shaft itself and begun to climb. With hardly a second to spare the cage had been hoisted. Its volunteer passengers, the much tried Andrew Cunningham among them, had dodged death by seconds.

Tom Walker and Betty, his wife, shared a house with another young couple of the same name. The women were keeping each other company and discussing the late arrival of the pit bus when James Walker's brother called.

"Is Jamie in?"

His voice was a shade too casual. It did not match the worry on his brow. The women looked concerned. Scarcely the time of day for social calls!

"Why, no. Not yet. What's up?"

He hesitated. "There's talk of a wee accident at the pit."

Unlike her sister-in-law, Jessie, Betty Walker was not a miner's daughter. Nor was she from Ayrshire. She came from Sunderland and was still a part-stranger to the spirit of the coal-fields. As she listened to James Walker's brother near-panic gripped her.

"Oh, dear Lord," she thought, "I *knew* it would come to this!"

She had been serving with the ATS when she met Tom. When he casually announced that he was a miner, she had felt her heart jerk. Darkness, danger, and death . . . Until then Betty's sole knowledge of mines and mining had been via the written word, or comments of her shipbuilder elders. Coal was something you heaped on a fire, rations permitting, when the

east wind bit harsh across the yards, or the steamer hooters wailed through the dank sea fog. Merely to contemplate how friendly coal was won conjured up an ugly, alien picture— broad headlines of disaster. Betty had been a kid when the Gresford disaster shocked the nation. But she had since heard about it and read accounts for herself.

"And I *knew*," she repeated inwardly, I *knew* it would come to this."

"It's probably nothing to worry about," James's brother said. She hardly heard him.

Tom had laughed so often at her misgivings, that over-stressing of the job's drama. In time she came to laugh too. But at least one of her early ideas proved well founded. When peril struck at a pit it did so murderously. She had never said good-bye to her husband without a secret qualm of fear.

"So I'll take a walk there myself," promised James's brother, "just to see that they're all right. . . ."

All right! She wanted to scream. To throw wide the door and run up the hill to the pithead. She wanted to be as close as possible to whatever was happening there. But Tom would not thank his wife for flapping about because of a mere rumour of accident. Tom Walker was a miner, proud of his calling.

So she kept her voice steady and said: "Thank you. We'd best wait for your news. . . ."

"Two chances we've got," said a miner, hearing of the break-through project. "One's a dog's chance . . . the other's no chance at all."

Rather corny, the sour jest still sounded grimly apt to the anxious men on the surface. The lives of the trapped back-shift and of their would-be rescuers depended upon precisely that—a dog's chance. Nothing more.

The drainage borehole was nearly two miles from the mouth of Bank No. 6. To reach it the rescue teams would have to pass through a maze of abandoned workings, maybe gas-filled.

No one knew the state of the roads. Falls of coal might have made them impassable. Again the roof might collapse at the first footfall. If such snags did not materialize and the Bank side of the barrier was reached, they still had problems. They would have to carve through the wall. Make a passage large enough for men—some of them stretcher cases perhaps—to pass through. In cramped conditions, without explosives and mechanical tools because of danger from gas, they would have to work with pick and shovel.

No wonder the conference members felt unhappy. Time was precious, never more so. At any moment all kinds of disasters might occur on the Knockshinnoch side.

"If more of the field falls," it was said, "the sludge will gain impetus . . . be thrust so hard that it may climb the slope of the West Mine, overwhelming the station."

Haunting MacDonald was the fear of gas in Knockshinnoch. By now the pit's ventilation must be completely disrupted: airways blocked: the main haulage-way to the shafts packed tight with sludge. Under such conditions a gas build-up was highly probable. Come to think of it there was yet another problem—ignorance of the road condition between the trapped men and the borehole. How could one be sure the Dook route was still negotiable? Maybe it was flooded. Or blocked by falls.

"One's a dog's chance . . . the other's no chance at all."

"Hullo, there!"

"Hullo . . ."

Walls and Tom Walker were faintly amused by the brief exchange of greetings following their meeting with Alec. The encounter certainly had not been over-demonstrative. Alec never was one for sentiment! Still they had glimpsed something of his relief at seeing them. The quick pressure of his hand, brief flicker of his eyelids betrayed the warmth of which he was ashamed.

"All right, lad ?"

"All right."

His safety established, they left him with his own crowd, pals of the haulage gang.

"Proud fellow, Alec," said Walls. "Doesn't need big brothers to nurse him."

"Aye, and good luck to him . . . but I wish there was someone to nurse *me*."

"Me too," agreed Walls feelingly.

Both of them became silent.

"Three brothers out of six," Houston thought bitterly. "The Walkers are here in force. Well, I had a brother . . . *once* !"

By now he had ceased to deceive himself. James was dead.

It was midnight in the Knockshinnoch Castle offices. A reek of tobacco smoke, babel of voices. Rain streaming down their coats, runners arrived from Bank. A doctor reporting for duty, volunteers being organized for the crater, where efforts had been intensified to prevent a further inrush. Four hours had passed since the first grumble of disaster. The pit buildings had become Control HQ.

One observer thrusting his way through the crowd to offer help found the atmosphere reminiscent of the war years. Perhaps because of that it was oddly reassuring. A Civil Defence centre coping after a blitz, had similar confusion. He felt this, too, was more apparent than real. The same good neighbourliness prevailed. Determination to work and not to "flap".

Attention again centred around the telephone. Once more it was Andrew Houston, symbol of the danger and defiance down below. Check calls were made at fifteen-minute intervals and these were anxiously awaited. Men found themselves glancing, almost subconsciously, at the clock. Even a few seconds' delay sufficed to arouse the fidgets.

The battle against the sludge was waged upon three fronts. It

was total war. George Paton, Knockshinnoch's chief electrical engineer, had been active out in Wilson's field from the start. He had run out several miles of cable to light the scene at the crater and provide a telephone link with Control HQ. Reinforced, with six trailers working, he planned a more ambitious project. The laying of a conveyor belt to carry earth and waste coal from colliery to crater to give substance to the sides of the hole. Despite the heroic efforts of Wilson and the other volunteers, the hole was in an alarming state.

Paton ordered "lights" as a fresh gust of wind blew over the bleak hill. Rain fell like spears upon the turf, transforming it in seconds from grey-black to emerald in the glare of arc-lamps. At least a hundred figures moved around the hole. In a sense they reminded Paton of kids running round a fire on Guy Fawkes night. Alas, the focus of all activity was no harmless effigy. It was a Thing, evil and animate . . . bubbling, frothing, guzzling . . . sucking the sparse earth to it: spreading out tentacles at all who dared oppose it. Paton felt sick even looking at it.

Trees, empty crates, rocks dragged from the hillside . . . desperately the workers fed them to the crater. The hope was to block it, thereby stemming the flow of mud and moss. Efforts were puny, contemptible almost, when ranged against the crater's greed. It took all they had to give and what they gave, it mocked.

Paton saw Wilson's tractor bound for the pithead for a "filling" from the slag heaps. Two men stumbled past, carrying between them the stump of a small tree. Their faces glistened with rain and sweat. One was still wearing his pyjama jacket beneath a drenched windcheater. A lorry arrived with a gang of farmhands. They began to pitchfork hay towards the hole. They worked frantically—and futilely. The hay disappeared, bales at a time, into the jerky flow of the sludge. Or wind-driven, flew in wisps around their bent shoulders.

Paton made a savage vow. "At crack of dawn we'll start

building that damn' conveyor. Four hundred yards long it'll have to be and built at record speed!"

At 2 a.m. Mrs. Tom Walker heard further news of her husband's plight.

"There's been flooding," her neighbours told her. "A lot of the men are caught there."

Mrs. Tom Walker summoned up her Tyneside courage. At all costs the crisis must be hidden from the children.

Houston said: "Rescue operations are under way. They've already started work in No. 6."

His assured tone deceived his audience. Little did they know the effort put into the act.

"Jaunty," a miner called Houston, speaking of future prospects. The jauntiness was totally unreal. A pose adopted for the needs of the moment. Though Houston feigned optimism for the benefit of morale, he was inwardly just as full of doubts. He had worked in Bank. He knew it and its history well. He had been oversman there before coming to Knockshinnoch, so could visualize the odds against rescue. . . . To him these odds seemed almost unsurmountable. He thought of the decrepit state of the workings which the rescue teams must penetrate, wondering how long he could maintain brave pretence. A great test of courage lay ahead. As a veteran he was convinced of *that*. Courage not only in fighting for life and in dying. Courage for the rescue-man and for the trapped. Courage to accept defeat and death with dignity, were the battle for survival lost.

"So it's just a matter of time?" Gibb McAughtrie asked hopefully; *meaning one thing*.

"Aye," answered Houston wryly, *meaning another*!

Few of those waiting in the West Mine shared the Bevin Boy's blissful ignorance of the true position. Still the general

mood was good. There seemed tacit understanding that fears be kept to oneself.

Making an elaborate parade of casualness, some of the men settled to sleep.

"Wake me with tea when the rescue team gets through," cracked one of them. The majority, however, sat around yarning. They kept their voices low, respectful as sightseers in a cathedral. There also were the super energetic; the few who just *had* to be busy making plans. One was how to defend the rear of the station against any further onslaught of sludge. Coal, pit-props, jackets—anything they could find, could be used to build a barricade. Far better to *do* things than to squat in idleness, waiting for God knew what.

"Barricade!" exclaimed a derisive miner to whom their scheme did not appeal. "And a hell of a lot of good your barricade will do! It'll be about as useful as a sand castle against the tide if the sludge catches up with us. It won't last ten seconds."

"*We* make it five," replied one of the planners coolly. "But we dinna care to advertise it. . . ."

"Pit Disaster! Over 120 Men Entombed!"

From the first flash, night news desks were cleared for action. By morning the Ayrshire colliery—"How the hell do you spell it, Jock?"—would become a household word. And over the black cavern of the West Mine—"Can't *anyone* draw me a map?"—would focus the hopes and fears of millions.

David Park did not guess the extent of anxiety causing NCB headquarters to blaze with light and officials to be recalled. Or how rescue teams were mustering throughout Scotland. Park was ignorant of the chilling message ticked out by the tape machines. Unaware of the drama enacted in his native Ayrshire. Fortunately still more ignorant of the leading role to be required from him. On the night express to Edinburgh, Park was sound asleep.

In his late forties, but looking considerably younger, David Park's was a success story. He was a Big Bug who had started very small. In appearance a stocky, well tailored chap, he had risen the hard way and very fast. Of a large family this pink-cheeked, almost cherubic looking character, had commenced his career as a saucy but cheerful pit boy, aspiring to be an oversman. Having achieved this whilst still in his early twenties Park had set his sights even higher. Shrewd and forceful he was now a prominent, much respected member of the coal hierarchy. Deputy Director of Labour for the whole of the Scottish Division.

At 11.30 p.m. a group of men, shoulders topped by oxygen cylinders, chests bulging with respirator cases, trudged in grim silence into the dark mine mouth at Bank No. 6. Had Park been able to see this procession four hundred miles ahead of him, he would have recognized its purpose immediately. But as it was he remained in complete ignorance of the events at Knockshinnoch. After taking part in a routine NCB London conference he had left to catch his train before the news broke.

By one in the morning the quiet of remote villages was being repeatedly shattered by traffic. Police cars, ambulances and trucks crowding in from Glasgow and Ayr towards New Cumnock. Seeing the rain glistening on miners' caps, the inhabitants soon guessed the purpose of the uproar. Several dressed, climbed on to bicycles and pedalled off behind the traffic to see how they could help. Still there was no hint of tragedy or suspicion of personal ordeal to come to haunt Park's slumbers as the train approached the border.

Knockshinnoch Castle acting as supreme headquarters, Mac-Donald was responsible for setting up and staffing an operational base at Bank. The task was unenviable.

Communications were complicated by the fact that Houston could speak only to Knockshinnoch. The gist of his information had to be relayed to Bank Mine either by GPO telephone or a runner. This system caused considerable delay. Phone

lines were overburdened and runners had to traverse a mile of rough country in the dark. Neither was there direct communication between MacDonald's surface staff at Bank, and the men seeking to set up an underground forward HQ. From there they would attempt to penetrate the old workings towards Knockshinnoch and reach the spot where it was intended to breach the barrier.

MacDonald reflected upon every sudden change that might affect the working methods and reveal either fresh hopes or further hazards. News transmitted by Houston to Knockshinnoch pithead, being passed on to the mine mouth at No. 6, then telephoned to a point at least a mile from the barrier. After that by hand, at probable risk to the messenger. Distortion of the message was another possibility. Eventually some of these problems could be lessened. MacDonald could have a direct line laid from the Castle to his headquarters at Bank. With the help of Coatbridge men he could have a sound-powered microphone installed at the underground base to cut delays in message-delivery below. But these innovations only partly solved difficulties of maintaining effective contact. Moreover they took time to organize. Every moment was precious.

The communications headache was not the only one worrying MacDonald and his men. Heavy equipment might be needed. How to deliver it? Two miles of treacherous workings, narrow and low-ceilinged, had to be negotiated.

Then there were the "admin." problems—feeding and shelter of the rescue men. Keeping them efficient and available for repeated sorties, when Bank did not boast even a pit canteen. Greatest worry of all was that the rescue operation might never get under way at all. . . .

The reconnaissance party going underground at 11.30 p.m. consisted of two rescue brigades. With them were McParland, Bank's manager, and George Rowland, HM Inspector of Mines. Much would depend upon the findings of this team. Had conditions on the Bank side worsened? Had there been

heavy falls or floods? Were gas concentrations present? Such questions required an answer before any rescue bid commenced. Only the men working their way below could supply that answer. Say whether or not it would be possible to approach the barrier, let alone cut through it.

An hour went by, then another. Still no word. The operational base was fully staffed. The rescue superintendent from Coatbridge had arrived with men and equipment to take over the preparation of a reinforcements' rota. . . . And still no news.

By 2 a.m. the impatience at base became extreme. So had the staff's anxiety. According to plan, the "recce party" should have returned. If not that, then at least have made a report. Quite obviously, something was wrong. Snags had arisen. The team was having to cope with them.

His chores on the surface satisfactorily arranged, MacDonald decided at two-thirty he could stand the suspense no longer. He would go down and see for himself.

5

OF SILENCE AND A PSALM

"TROUBLE!"

Hurled back from the scarred and shattered roof, the word roused strange echoes. It brought the men of the "recce" team, stumbling in single file through the coal-littered and long neglected tunnel, to an uneasy halt.

A curse or two was followed by a silence lasting until the darkness ahead of them was broken by a wavering splash of light.

Lamp in hand, the leader rejoined the column. "Firedamp," he said briefly. "The place is full of it."

Bitterness struck like a knife into their bellies. "Firedamp! *That's* bloody good."

Considering the circumstances they had made fair progress. The roads had been clear, but the going tough. Bowed by the weight of their equipment, bruised as their thick-soled boots slid from beneath them on the shelving, slippery pavement, in desperate haste they had had to shore up loose patches of wall threatening to collapse upon them. Hands and fingers were cut on the rough edges of the stone. Yet until this moment the sum total of their effort had been rewarding. Until this moment . . .

Firedamp contained methane gas, explosive, inflammable. The slightest spark from pick or shovel could transform the rescue route into a flaming hell. Nothing would confront the rescuers but a heap of sticky ash. Should an actual explosion be averted there were other dangers. Firedamp was a

strangler. It might asphyxiate the men in the West Mine if the barrier be holed.

"How far are we short of the barrier?"

The leader shrugged. "Five hundred yards as near as maybe—and the gas is as thick as hell."

Silence, broken by the drip-drip of the water from the tunnel's slimy walls.

The men could not see or smell the age-old enemy across their path—an enemy revealed only by the way in which the bluish halo over the safety lamps' low flame transformed itself abruptly into a tiny, climbing spire. They knew all there was to know about the lethal threat. Far worse than any result of flood or fall.

"So what happens now?"

Watched dully by the halted teams, half a dozen shadowy figures of leaders and officials merged into the centre of the road. Their helmeted heads were bent. Their feet dragged through giant puddles. So thick was the dust forming upon the water like a scum, that the lamps failed to extract a single, cheerful glimmer.

Consultation was brief and business-like. Decision unanimous.

"We're moving on." The word went down the line . . . "We're to check the state of the road by the barrier—in case they can get rid of the gas."

Despite the lurking menace in the blackness of the ghost mine, it was with a sense of relief that the "recce" force adjusted breathing apparatus and resumed its unsteady advance.

Firedamp. Concealed for tens of thousands of years it was a product, as coal itself, of the steaming primeval forests lapsed into decay. Like the sludge, it had been harmless enough until Man began to tamper with it: sleeping, silent, a prisoner of the seam. But when Bank had taken over the fields above, and quested into the inert strata below, the gas had awoken and begun to stretch. At first its build had been feeble and

unsure. Reaching thinly from the cracks of its prison into the space that Man's hand had provided, it had been shattered by the blast from the airways, dispersed by the pressure of mechanical fans, but since the workings closed and the main ventilation system was shut down, firedamp had come back. In the tunnel below the crossroads it formed an invisible curtain —far tougher than the barrier of coal and rock—between the rescuers and the trapped.

Not that the majority of the latter knew—yet!

"Best to say nothing," Houston advised cautiously. "They've enough on their minds already without our adding to it."

The fireman nodded.

They had heard nothing from the top since the signal that a rescue bid might be attempted from the Bank. Several hours had since passed by but pithead was unable to tell them of the progress. From this long silence the veterans drew shrewd, disquieting conclusions. Still they agreed that some things were best left unsaid. Plenty to occupy them besides talk for talk's sake!

The air in the West Mine was a constant source of worry, as the atmosphere had been disturbed by the impact of the fall. With the sludge blocking the tunnels providing nine-tenths of the ventilation system, the balance of life-giving gases had been upset.

Keeping his voice low, Houston said, "That was sensible, man—your testing for gas at places where they couldn't see you. It might have unnerved some of the younger lads if you'd made too much of a parade."

"Aye," answered Capstick dourly, to add, "Well, it's negative so far, but God knows how long it'll stay so."

A pit boy detached himself from the crowd and began to wander down the tunnel. He had an empty bottle in his hand. Houston called him over sharply.

"And just *where* do you think you're going?"

The youngster looked furtive, ashamed, shuffling before the oversman and his deputies.

"To the barrel—I must have a drink."

"You'll do that only under orders." The words came roughly. "Get back to your section !"

The youth shambled off. Following the sulky retreating figure with his eyes, one of the firemen commented, "A queer old thing to think that in that bloody old barrel is our entire water supply."

"But he must have a bloody sore thirst though—to want to drink that muck !"

They laughed, though somewhat falsely. The water had been stored for use in wet-drilling; and on its surface floated an evil mixture of grease, coal-dust and rust. It stank like a compost heap.

"Sheer, bloody daft, that boy," continued the fireman. "But he's not the only one, Andy. I stopped another, slipping off for a drink when you were on the phone. Angry as hell he was . . . what right had I to interfere? I told him I'd lay him out cold !"

Good God, despaired Houston inwardly, just to think that two of them are beginning to break already ! Soon we also will be feeling the way they do. Unless, of course, the gas attacks us first.

Aloud he said : "Mark you, the water should be safe enough just to wet the lips; but I'll warn the men they mustn't do more than that."

A few minutes later he put through his usual check call to the surface. They sensed the question he dared not ask.

"No news from the Bank yet, Andy. But bear up. You're not to worry."

Not to worry !

Polite with an effort, Houston replaced the receiver and propped himself against the wall. He felt very tired . . . suddenly old . . . extremely sad. To his right they had turned

on the light of a diesel locomotive, parked at the station.
The slim swathe of light only seemed to accentuate the weight
and depth of the darkness. On the left blackness reigned
supreme, a cloak for the creeping sludge.

He closed his eyes. His head began to nod. All at once the
brooding silence fallen over the company was broken by men's
singing.

Softly, slowly, the hymn began. At the start only a few sang.
By the end of the first verse others came in with them. Soon the
whole of the West Mine united fervently in the refrain:

> On a hill far away stood an old rugged Cross,
> The emblem of suffering and shame,
> And I love that old Cross where the dearest and best
> For a world of lost sinners was slain.

In reverent unison the men sang. No trained choir, thought
Houston, could have surpassed them:

> So I'll cherish the old rugged Cross
> Till my trophies at last I lay down:
> I will cling to the old rugged Cross
> And exchange it some day for a crown.

War Cry in the pubs . . . a cluster of peaked hats in the High
Street, spectacled faces, pale and thin beneath prim bonnets
. . . eyes half closed, the men in the West Mine saw far beyond
the rough roof and present pain to dwell upon the past.

> O that old rugged Cross, so despised by the world,
> Has a wond'rous attraction for me:
> For the dear Lamb of God left his glory above
> To bear it to dark Calvary.

Most of them had laughed at the "Army" with its

"citadels", its prayers for sinners, the deep throb of its brass in the pulsing Saturday nights. . . . At this moment all these things seemed homely and desirable. Symbols of life and hope.

To the old rugged Cross I will ever be true,
 Its shame and reproach gladly bear:
Then He'll call me some day to my home far away
 Where His glory for ever I'll share.

To his surprise Houston found tears in his eyes. He thought of John Dalziel—Dalziel the Salvationist—father of nine. The hymn was a favourite with the "Army man". But for once Big John was absent from parade.

Then the singing stopped. Silence was resumed. Houston's mind strayed back to his childhood. He fell asleep, though only for a few minutes; he awoke in near-panic, mourning James, his brother.

Andrew's broth prepared, at 11.30 p.m. Margaret Cunningham drew it off the stove to season. She left it to simmer slowly. And then like so many other waiting wives she peered into the darkness, impatiently at first, later with concern.

When she heard the first rumour—that under-statement that told of "trouble" at the pit—she called her brother Hugh.

"Not to take on," he said. "I'll away and look for Andy myself."

Hugh was good as his word. But hours went by and he did not come back.

Margaret hailed a passer-by.

"Cheer up," he replied, "and be as patient as you can. Your man will be all right. I'm going to the pit. When I have some news, I'll come back and tell you."

But he did not.

Margaret Cunningham was approaching collapse when

young Billy, aroused from sleep, entered the living-room. "Ma, why are you crying?"

As gently as she could she tried to explain. No sooner had Billy heard the first two sentences than he started to pull on his clothes.

"And what are *you* up to?" she asked.

"I'm away to the pit to look for my daddy."

He was gone before she could recover from the shock that her fifteen-year-old son should have spoken with the authority of a man.

Fast though young Billy went he was slow in returning.

After another hour of waiting Margaret Cunningham struggled into her raincoat. "I'll have to go myself. I can't stand this hanging around...."

She paused. No, she could do no good by visiting the colliery. Whatever was happening up there it would be men's work to right. A woman would be in the way : a nuisance. Her place was at home.

Margaret Cunningham took off the coat, replaced it upon the hook. For a moment she stood undecided before the laid supper table. She felt she had to be busy so, for want of something better to do, cleared the cutlery. The broth would be wasted now. When Andy did come back he would not want broth for breakfast !

If Andy came back ...

The operational base at Bank being staffed, MacDonald was free to do as he wanted. Go into the old workings and see how the "recce" team fared. He was accompanied by Eric Richford, District Inspector of Mines. They met the team returning to the surface. The news given was discouraging.

The road ahead was accessible in as much as they could pick their way along it. However, the gas was worse than they had feared. An old-type booster fan, left in the derelict workings to

ventilate the pit pumps, still functioned. Its effect was limited to the static defensive. One hundred feet ahead the firedamp, unstirred by the feeble draught, ruled. From its frontier just beyond the cross-cut it extended a quarter of a mile. Right back to the barrier itself. Knockshinnoch, with the gas in the way, seemed remote as the moon.

Said MacDonald, "We'll *have* to clear the stuff."

It sounded a tall order.

"We'll bring in more fans. And pumps as well, if needed."

"But *how*?"

"By hand," MacDonald replied. "Unless you know an easier way!"

The snigger of appreciation masking a tensing of nerves. By all normal standards the task *was* impossible.

Bank No. 6 no longer had a haulage system. Every piece of equipment required to clear firedamp would have to be dragged to the site by a sweating human chain. Tubes, fans, cables and switchgear—every damn' thing they needed—would have to be brought in manually. The route was two miles long, the going hard even for unencumbered men. A real bastard! How the hell were they to move the heavy stuff? Ton after ton of it, through this crumbling, derelict warren, where the walls, roof, or both, might collapse at any moment. A race against the clock they'd heard it called up top. How to start under such outrageous conditions? It was ridiculous even to attempt the job except that, short of complete surrender, no alternative existed.

"For we've *got* to do it." One of the team spoke for them all. "*We've just got to do it.*"

It was three in the morning: New Cumnock had woken early.

Windows were no longer dark. The street was noisy with transport. Three hours had passed since Mrs. Dave Jess, fidgeting when her husband did not return, first noticed the

people opposite peeping at her through their parlour curtains. At first she could not think why. The neighbours had known about the Fall, but had not dared to tell her even when, pityingly, they saw her looking for Dave.

"You should go over and speak to the lass. It's right that she should know," the wife had said, nudging her husband to action.

The miner did not move. "Aye—but it's you who should be doing the telling. It's a woman's job—breaking news like this!"

So this matrimonial dispute had gone on until finally the neighbours did nothing.

They were relieved when they saw her father arrive. Best leave things to her own folk. Best let him break the news. Strangers were out of place in times of trouble.

She answered her father's knock. He could have cursed aloud when, seeing her face turn white as the tablecloth, he realized he was the first with information.

"I'm sure Dave will be okay," he mumbled finally.

She did not answer. She turned away to kneel beside the cot where Dave's son was sleeping . . . resting her forehead against the rails. There was no sound save the ticking of the clock—no movement from her save the clenching of a hand upon the woodwork.

"Work is proceeding as planned. We'll let you know more later."

Telephoning to Houston officials spoke with cheerful briskness. They contrived to conceal their grave anxiety. It was daunting to contemplate the difficulties of rescue. A pointer to the general feeling lay in the sombre wording of a report put out by the tape machines at three-thirty on Friday morning.

"If, as is feared, there is little hope for the 128 men, this will prove to be the biggest mining disaster since Gresford."

There were times when to hope at all seemed presumptuous.

Down in the Bank Mine MacDonald and his men established their advance headquarters. The first auxiliary fan was on its way from the mine's main road. It weighed five cwt. and was nearly six feet high. Half-dragged, half-carried, bobbing and bowing above the straining backs of the blasphemous men it burdened, its progress had an air of macabre carnival. To one official at the Fresh Air base its swaying, jerky advance resembled the image of some pagan god, borne in procession. Lacking only were the sunlight, the flowers and the laughter.

Despite the tricky going the fan was moved with such dispatch that even MacDonald's impatience was appeased. The cumbersome machine had travelled as fast as the men could walk. Electricians and engineers accompanied it. Rescue men, too, wearing breathing apparatus. They positioned it and to its snout secured a series of canvas tubes extending for nearly fifty feet into the gas-filled area ahead. Throughout the entire operation—from dispatch of the fan from a neighbouring colliery to its installation in No. 6 there had not been a wasted moment. The air began to pulse through the tubes. Air pumped forcefully at its "target". For the first time MacDonald experienced hope.

His aim was to drive a "roadway" of fresh air right up to the barrier itself. Should the barrier be breached, the trapped men might walk to safety along this roadway. The objective was ambitious. There were literally millions of cubic feet of gas ahead of the fan. Furthermore the hoped-for "clean" area would have to be created in double quick time before gas, or sludge, built up on the Castle side. As the tubes bombarded the structure of the foul atmosphere, he felt his desperate aim might succeed.

The fan removed the firedamp with enthusiasm, blasting it from the front, scattering it to the flanks of the throbbing tubes. The fan worked efficiently and vigorously. *And it very nearly killed them.*

Firedamp is a fickle foe. To prevent it asphyxiating, it must be banished. But another lethal problem is then presented. How to prevent it from bursting into flame. When constituting 5 to 6 per cent. of the atmosphere, firedamp burns only at the source of ignition. When its proportion rises to between 12 and 15 per cent., the whole mixture burns, slowly but steadily. Between these extremes (described by textbooks as the "lower and upper limits of inflammability") the gas is highly explosive. At this stage sufficient oxygen remains in the atmosphere to enable a flame to pass through the mixture so rapidly that a big bang occurs. This blast is followed by a chain-reaction of flame, outstripping even the fastest runner.

MacDonald, who was thinking that things were improving, discovered, with horror, his mistake. The firedamp's apparent surrender was full of deceit. The fan's reduction of the volume of gas was not increasing the men's chances of being brought to safety. Instead it was creating opportunity for additional disaster. A super-colossal tragedy. In weakening the asphyxiating quality of the firedamp, the auxiliary fan was now disseminating an explosive mixture which hurled back through the workings and passed over the old-type fan used to ventilate the rest of the mine. *This* fan had an open motor. When the slightest spark easily could prove fatal, the firedamp was surging over what might turn into naked flame!

There was a quick conference with the District Inspector of Mines.

Work was brought to a stop.

Andrew Houston glanced at his watch. Up top it would be dawn. Grey light brightening between scudding clouds, with the raindrops like diamonds on the emerald turf, and wild birds soaring from behind the bald hills. It would be fresh and cool up there. Soft on the eyes. The man turning his face from the scarred pithead would feel the wind's keen touch upon his cheek ... and take deep gulps of it, pure as mountain water.

"Christ, I could do with a fag," said a fireman licking his lips.

"Not like *you* to want to break regulations. Besides smoking's bad for the health."

"They're bloody silent up there about the way things are going."

"Well, it's bound to take a bit of time. That Bank trip can't be funny."

They were still pretty calm in the West Mine. If not, they pretended to be. Houston felt vaguely proud of them. Still it was true what the fireman had said—high time they heard something more definite from the surface. Several hours had passed since the first indication of the attempt through Bank. The subsequent silence might be considered ominous.

Regarding such men as he could see in the darkened road with detachment, Houston became aware of a curious phenomenon. He was still sweating. It was as if the pit were filled with tropical heat. Yet some of the shift appeared quite cold.

A pile of sacks had been found at the side of the West Mine station, and were being used as blankets. Even this protection did not stop the miner nearest to the phone from shuddering as he lay upon the pavement. Outlined against the subdued light of the pit lamp he shook as with the ague.

"Wonder what the temperature *really* is like?" pondered Houston.

The fireman also had been considering the matter. "Oh, it's hot enough—must be, with the ventilation shot to hell. But maybe it's not so hot as you and I would think. Maybe it's our nerves that are to blame. That chap over there finds it cold. It doesn't mean he's *cool*, poor devil."

Time for a further call to the surface. Houston thought: "Every damn' time I go to this telephone I ask the same question. Is it working? Or will I find it seized up? Will I hear the voice of that lucky chap up top or only bloody silence. And if

we are still through, what will they say to us? Precious all!"
His hands were wringing wet and shaking slightly: "West
Mine here..."

As usual, conversation was brief and unsatisfactory.

"Nothing fresh," he remarked, replacing the receiver.

"You should try to get some sleep, Andy."

"Me? Oh, I'll stay awake a wee bit yet." He forced a grin.
"I'm not one for sleeping in the day-time anyway ... wake up
bad-tempered, like a bear with a sore head."

Houston knew there was a lot to be said for the fireman's
argument. They might all need sleep, and the strength that
came from it. But though his lids were as stiff and heavy as
metal, he did not want to close them. "Silly, yet there you are,"
he thought. "I just don't want to sleep." He hated to think of
the blackness that closed eyes would bring—the deeper black-
ness that would replace the broken one of the pit. Sleep was
death's close relation: he must strive to keep awake.

To engineer George Paton, waging a war against the
enemy's second front—the hole in Wilson's field—it seemed
that the dawn loitered with vindictive intent.

Though he had been fully occupied throughout the night
coping with countless demands upon his skill, Paton itched to
start work on the conveyor belt; a project planned for day-
break. Once under way, he reflected, that belt could deal with
big consignments of "filling". Bring over quantities of material
to block the cracked opening to the heading. In fact stem the
onflow of the peat and provide stability against additional
collapses threatening to bring the entire field down.

When at last the murk cleared and it was time for the
impatient engineer to commence, he was astounded by the
spectacle revealed by the pale light. The hole had become
monumental. Police were lining the rim of a fifty-yard-wide
chasm. Its sides were littered with debris: felled tree-trunks
heaved on a sea of black and mud-yellow.

"Good God!" ejaculated Paton.

The remainder of the area, designated so recently by experts as "good agricultural land", showed deep scars made by the tyres of his trailers and the caterpillars of Wilson's tractor. Cutting into the soggy surface these grooves interlaced like the vapour trails of manœuvring aircraft. Intricate as this motor-made tapestry was, Paton and his companions hardly noticed it. All eyes were upon the Hole.

"It'll take some filling," a visiting official commented.

Paton shrugged, gesturing with his head towards the slag heaps near the pithead. "Plenty of stuff there. The main enemy's the clock. Just to think," he added with bitterness, "if this had happened a month ago we'd have had daylight an hour sooner."

"One thing about it, you won't be short of labour."

"No," answered Paton, his hard gaze softening, "we'll not be short of *that*!"

The men who wanted to help had mustered in strength.

There was the chap who had called in his Sunday Best to inquire about a friend, then, seeing how things were going, volunteered for the Bank Mine. In the first fifty yards he had ruined his blue serge suit, but merely cracked a joke to a sympathizer: "Och weel, man . . . it's nae matter. I'll be getting anither when I've saved my Co-op divvies."

His attitude was typical of the spirit of the hour.

Paton reflected that there also were those who might have been expected to have had enough already. Having escaped death so recently at the pit, for them there must be every inducement to stay out of further trouble. Yet there they were, still labouring away—people like Andy Cunningham. Despite his ordeal below he was now so busy working he had no time even to reassure his family.

Oddest and most unexpected of the volunteers were those who had no idea what to do. Yet they turned up, pleading to help with *something*. Among them were several non-miners.

In the past these helpers had regarded the miners' close brotherhood with suspicion. Condemning its radicalism, industrial and political solidarity, also what they considered its persistent complaining. But they were solidly with the mining folk this day.

"Back-shift, day-shift and night-shift—and folk who aren't *us* at all. It's all one gang now," thought Paton. "And bloody fools we'll look, if we let each other down."

From an aircraft diving low over the field a Press photographer took the black scar of the crater. He observed what appeared as a slim grey finger from the colliery's outer rim. The men busy around it, stooping low as they laboured.

"What are they up to over there?" he bawled to the pilot.

The other shook his head. "Ask me another! It's too far from the scene of the crime."

Paton & Co. had begun their building operation.

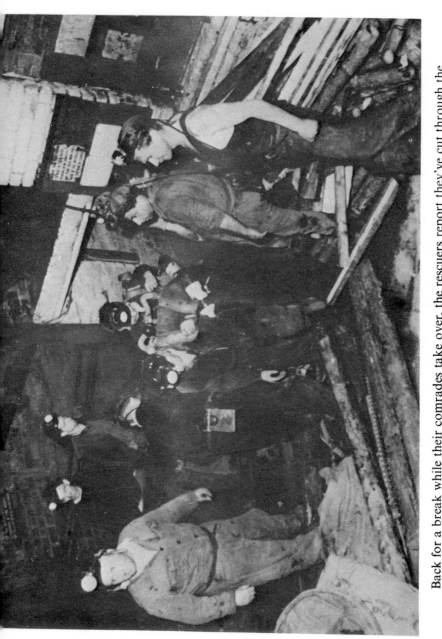

Back for a break while their comrades take over, the rescuers report they've cut through the coal barrier, but the gas has clamped down on the gap.

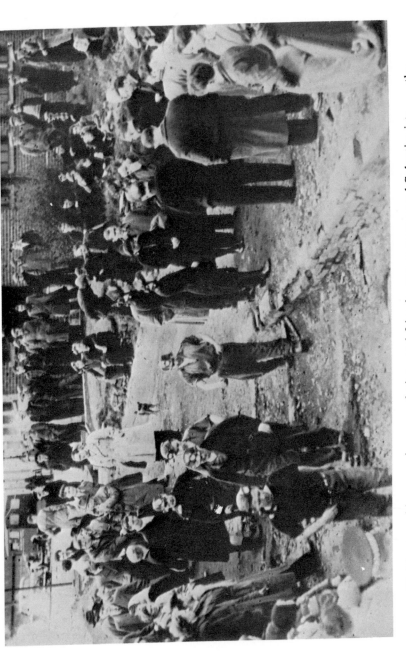

Waiting, working, praying . . . relatives and friends, rescue teams and Salvationists . . . the pithead is watched by a world that's awed by their sorrow and hope.

6

"TO FIGHT OUR WAY"

O N Friday, September 8th, a shortish, well-turned out
man, plumpish but not fat, rubbed the sleep from his
eyes and stepped from the train at Waverley Station,
Edinburgh. He sniffed affectionately at his native air. Ambling
up the platform he turned off towards Princes Street.

It was seven-thirty in the morning. He thought of breakfast
when he reached the top of the steps and bought a newspaper.
The headlines hit him like a punch to the heart.

"Pit Disaster . . . 129 Men Trapped."

The paper-seller was shocked by the way Park stood there
gaping. Dark hat, heavy suit, brief-case and all the rest of it:
prosperous businessman to look at, yet he reacted to the front-
page news as if he had seen a ghost.

"Oh, no!" exclaimed the Deputy Director of Labour,
Scottish Division. "Oh, no, it *can't* be Knockshinnoch."

"Dreadful news, sir . . ."

Park did not answer.

"A pretty tall order to get that lot out . . ."

Park hailed a taxi.

His appetite had vanished; so had thoughts of going home.
Instead he told the driver to take him straight to the office. But
more than a five-minute ride was needed for him to sort out
his confused thoughts : Knockshinnoch was part of his own life,
his youth had been spent in the New Cumnock coalfield, his

father lived there still. Park, of the success story, had been born there, grown up in a cramped cottage, one of a family of nine. Rough days, those of his boyhood, yet always he had looked back upon them with affection and no bitterness.

The taxi was held up by the traffic lights. The driver said hesitantly : "Think that they'll get them out, sir?"

Get them out? They *had* to get them out!

Inwardly Park panicked. He thought of those whom the disaster might involve. His uncle. Was he not on the back-shift nowadays? The Walkers. How about them? They used to live next door. Park glanced again at the newspaper. The story was of necessity vague. He found scant detail and no comfort at all. He and Andrew Houston had been friends for the past twenty years. There also would be Houston's brother . . . maybe *he* was down there. Park's gloom increased. Relatives, friends, companions of boyhood . . . now actors in this tragic drama played against a backcloth that symbolized the youth which Park had left behind him.

When the taxi turned in to the dignified Georgian crescent which housed Scottish Division's HQ, the usually genial face of the Deputy Director of Labour wore a dark, determined scowl. Knockshinnoch was his home. High time he went there!

MacDonald came out of the mine-mouth at Bank at 8 a.m. with a message for relay to the Castle and thence to the trapped men. Filthy and bone-weary, he spoke with restrained optimism. A "recce" party had toiled up the gas-filled slope ahead of the Fresh Air Base and penetrated the derelict workings to a point just beyond the place where they hoped to breach the barrier. It appeared that at long last the gas was on the move. Reinforced by new equipment, the fan crews had cleared 300 feet of it. Much still could go wrong, of course, but at least there had been some progress.

Queried a reporter, "Then everything's okay?"

A rescue worker answered with irony: "Oh yes—except that the roof may fall, the gas come back, or the sludge start to rise again and overwhelm the West Mine." He paused, " So I'd not be in too much of a hurry to use the word 'okay', if I were you. Some of your readers might be misled."

"Did ye no ken, then?" The bus conductor's voice was high-pitched with shocked surprise.

Going on day-shift, Pup Walker stood indecisively on the platform. The bus remained stationary. As Pup clutched the handrail he felt as though the floor was slipping from underneath his feet.

"No," he answered weakly. "I didna' ken."

A second or two earlier he had been astonished that none of his cronies were aboard the bus. Now he knew why. They were already at the pit, trying to cope with the disaster of which, until now, he had been blissfully unaware.

The conductor still did not ring the bell.

"Your boys . . . they all right?"

One look at Pup's face supplied the answer.

Two hours had passed since MacDonald's preliminary situation report upon Bank No. 6. Area General Manager McCardel, with a glimpse of snow-white handkerchief above his breast pocket and stiffly laundered shirt sleeves protruding from the cuffs of his immaculate jacket, felt the rescue plans sufficiently advanced to communicate with the men below.

From the tips of his highly polished shoes to the level parting in his unruffled hair, McCardel looked the typical dapper executive. The brain above his high forehead was as orderly as his lounge suit. His issued instructions were explicit. He was a stickler for detail. This trait was just as evident in the present crisis, as Houston noticed. The message—just received in the West Mine—had been cool and carefully phrased. So was the instruction to repeat it and write it down word for word as

received. Repeated by Houston, transcribed by a responsible deputy.

"Tell the men," echoed Houston slowly, "that the gas is on the move. The rescue team has been past the place where the bore is. The bore is twenty-four feet thick. It is hoped to give you definite instructions in one hour's time . . ."

There was a murmur of excited approval from the darkness. McKnight, writing laboriously in his round, easy to read style, shook his head impatiently, anxious not to miss anything.

"The oversman," Houston continued, "will proceed, accompanied by a volunteer, to the site of the bore hole, and return to report by phone that there is nothing to keep them from getting there from the Castle side. No operations to start until definite word is passed on . . ."

Silence was broken only by Houston's voice, kept carefully controlled, and the slow scratch of the pencil.

So far the plan envisaged what he himself had hoped. A chance of salvation for all of them. The message stated that the rescuers would dig towards the Castle. For their part the trapped men would dig towards the rescuers.

"When word is given to start," McCardel said, "commence on the middle leaf for about sixteen feet and then rise up to the top leaf for holing through."

What if the gas were not cleared by then? Might not it roll through the opening to stifle the Castle men? The thought had scarcely occurred to Houston before it was answered. When the gap was narrowed to a point where a break-through became practical, work would be suspended while a small bore hole was driven through the barrier. An atmosphere test would be carried out. If the air blew through the hole to the Bank side, the men would resume tunnelling. "But," emphasized the message, "if the gas is coming towards the Castle, *stop the bore hole.*"

The waiting men muttered. This mutter was not so pleasant-sounding as before and Houston gestured for silence whilst he

repeated: "The oversman must control his men carefully. If the gas is out, he will be given the okay for the men to travel..."

"Sounds like business at last," thought McKnight hopefully. Houston considered the implication of the pay-off. The voice at the other end had said, awkwardly, "if the gas is *not* out, the oversman must control the men on his own side until instructions are received. The oversman must arrange that the men take short spells and husband their strength."

Houston glanced furtively at McKnight. Framed by a sort of halo from the lamp, the fireman's face was quite inscrutable.

Back from the bus stop went Pup Walker. He walked wearily, shoulders bent like an old man. His duty was to break the news to Mary. He must do this before she heard it accidentally. Unprepared, she might be felled by the brutality of the blow. As the bus started up and he heard it change gear to resume its journey to Knockshinnoch, Pup Walker felt that as though half his heart went with it. . . .

Meanwhile in Edinburgh, David Park was listening, almost incredulously, to what they told him about the cause of the disaster. *Peat?* He could scarcely believe his ears. Nowadays workings were never driven close to peat. There were the most rigorous regulations governing mining in areas known to contain deposits of peat or moss. Maybe they had not known? The very thought seemed fantastic. All land had to be very carefully surveyed before men were set to work beneath it. So why should Knockshinnoch be different? Anxious to reach there quickly, he decided that such questions could be left to the inquest.

"Felix," thought Houston, "that's me . . . Felix the cat who always kept on walking!"

It was uncannily quiet in the tunnel leading to the Dook. Even the fireman's footfalls gave no responsive echo. The low

roof and damp walls absorbed and stifled the dragging note of
boots moving slowly, laboriously through the coal-littered route.

It had been dark enough in the West Mine; here it was still
blacker. When they stopped and tested for gas, lifting their
lamps towards the wet-beaded roof, they were in a lonely world
of their own. No longer could they hear anything of the main
body of the men. When they spoke to each other they became
abashed by the brooding silence and dropped voices to a grave-
yard whisper.

The tunnel which broke from the West Mine at an angle of
ninety degrees was some 800 feet long. When eventually they
reached its junction with the Dook they hesitated a moment
before proceeding. What would they find? Maybe a heavy
fall? If they did, *all* hope would have gone. Fears dragged at
them as they turned the corner. Fears weighting their ankles
like a fugitive's ball and chain.

The dank, sour smell of the Dook stung their nostrils and
palates. The feeble aura of the helmet lights lit gaunt skeletons
of rotting timbers, a patchwork formed of thin veins of water
interlaced with slime. Soles squelched dismally through a
mash of wet coal dust. The men slipped and slithered on the
treacherous surface, harassed by fresh worries. So far the road
was open, however unpleasant the going, but the small turning
that would take them from the Dook to the barrier might hold
its own menace. Dipping from the side of the Dook it formed
a sort of hollow at the point of termination : the dividing barrier
from the Castle to No. 6. That hollow formed a perfect pocket
for lurking gas. Confined, it would be prevented from
dispersing by the angle formed between the slope and the solid
face.

Gas . . . should their fears be justified it would be impossible
for the trapped men to help reduce the gap separating them
from the rescue teams. *Should* the masked Bank party succeed
in doing this job unaided it would be in double the time of a
joint enterprise. More precious hours would be spent dispelling

the gas on the Knockshinnoch side before the men could emerge. Every second was vital to those waiting in the West Mine. Houston dreaded returning to them with news of fresh defeat.

At the turning from the Dook they once more raised their lamps. A small blue flame with a speck of yellow in the centre; above the fuel cap, a faint line of paler blue, almost indiscernible. The fireman turned, his teeth gleaming in a grin; "Okay, okay."

They slid down the slope towards the barrier, and again paused.

Houston's palm was clammy against the metal base of his lamp as slowly and carefully he raised it to eye level, then higher still. The flame continued to burn low. The fireman passed his lamp equally slowly across the walls. There were crevices, natural receptacles for firedamp. After a few seconds he stopped, satisfied. The place was clean.

"Okay," said the fireman. "It really is okay."

They were still praising their luck when they approached the blackness on the other side of the hollow : a blackness of a far different texture to that of the dark. An immobile blackness which defied and hurled back the shafts of light from their helmets. The kind which Houston could feel and grab hold of as he extended his hand.

"*This is it,*" he declared. "*We've reached the barrier.*"

For a moment longer they stood there, savouring the importance of the moment, thinking how little, yet how much, stood between them and the living world. Twenty-four feet; four times the length of a coffin.

Houston spoke sharply. "We'd best get back. I must telephone the surface to let them know the road's clear. We can start work right away, if things are okay on their side."

Suppose that they were not?

The eyes of the world were upon Knockshinnoch and the

slim-seeming barrier between freedom and the trapped men. Had goodwill been sufficient that obstacle would have collapsed like the walls of Jericho. From all over Britain came offers of help sent by people of every class and interest.

A thirty-five-year-old water diviner put through a call from London, offering his services "to trace the whereabouts of the missing men". His specialized knowledge had been tactfully declined. Despite his misunderstanding of the real problems of rescue, the offer was well-meant and generous.

Locally, Hugh Blackwood, a roadman employed by the Ayrshire County Council, had been equally eager to help. Like the offers of many other manual workers who did not "belong" to the miners, his was gratefully accepted.

Another arrival at HQ was a military man. He could not see why the devil everyone was so alarmed when "a series of explosive charges would clear the way in seconds". He was abashed when they told him about the gas. He atoned for his criticisms by reporting for work by the crater.

Probably the most successful "amateur" of all was Charles Fleming, manager of the local branch of the Commercial Bank. Early Friday morning he had been asked to help alert doctors, ambulances, and hospitals. He did the job thoroughly, but wished to do more. Finally, having shelved his workaday routine among the ledgers, he found himself in charge of No. 6's solitary overtaxed telephone. Assisted by James Bigg, of the NCB, he was to endure a forty-eight hour stint.

The Castle canteen staff worked voluntarily through the night, without a break, to feed rescue workers and anxious relatives. When local women heard there was no canteen at Bank, they organized themselves together with members of the Salvation Army, and set up in the former pit baths.

"But where did you get the food?" asked a miner.

"From our larders," answered a volunteer. Seeing him hesitate, she added, "And you're very welcome. My husband's

down there. He's on the other side over in Knockshinnoch. He'd no grudge you his supper."

Recalling the incident many years later the man was to say, "She was a brave lass that, but she almost took away my appetite. You see I happened to know that, down in the pit, things had taken a turn for the worse."

Lights . . . scores of lights . . . glittered in the tunnels of Bank No. 6. On each side of the long route leading to the Fresh Air Base, men were busy shoring up roofs and timbers; moving in as reliefs to the teams fighting the gas. Despite the business-like appearance of the scene there was a feverish anxiety amongst officials contrasting ominously with their earlier measured confidence.

Houston had made his report upon the road to the barrier still being open on the Knockshinnoch side. He had been ordered to stay put. Everyone at the base knew why. The battle against the firedamp was not going "according to plan". For every few cubic feet that the fans succeeded in clearing massive reserves of gas welled up from the long-neglected roadway. The teams advanced steadily for a while, extending the canvas funnels of the fans farther and farther into the gas; nearer and nearer the Barrier. Just after McCardel's message to the men, however, the gas counter-attacked with unexpected force. The men were driven into retreat. Now, brattice sheets had been erected. These were improvised barricades stretching from the floor up to a few inches of the ceiling. "Traps" to concentrate and divert the air currents, directing them to roof cavities where lay the bulk of firedamp. The gas still ebbed and flowed, each temporary triumph of the rescue brigades being followed by a reverse and bitter disappointment.

Over the nose clips of their breathing apparatus the advance party gazed grim-eyed at the wall to their right. At one point— they would not know precisely where until they heard the picks of Houston's men—only twenty-four feet separated them from

the trapped. Twenty-four feet—might as well be as many miles. The major obstacle to progress was invisible; the poison that could kill a man in seconds.

"Castle men have been on the phone again, asking when they can start," said a worker back at Fresh Air Base.

"Poor bastards. What did they tell them?"

"To stay there till further orders. . . ."

"At this rate they'll stay for ever."

Tommy Walker's first-born came running to his mother. His chubby face streamed with tears. He could hardly speak for sobs.

Betty had allowed him out to play up to a few minutes before so that he should not sense the fear that gripped the house. Now she wrapped her arms around him, anxious to soothe.

"What's wrong with you?" she asked, but already she knew the answer.

"They say that my Daddy's in a big black hole," he wept. "They say that my Daddy's in a big black hole." He kept repeating the savage words like a gramophone record stuck in a groove.

Betty Walker thought bitterly, "*Some* people are swine, swine, Swine!" And then, she too, began to cry.

Walls Walker opened his eyes, a brief nap ended. Yawning he reached out for the alarm clock. His fingers could not find it. "It's early . . . still dark . . ." he thought: then it all came back to him . . .

He sat up, aching in every bone. Tom's dark shape lay huddled asleep beside him. He envied his brother his slumber of exhaustion and despair. Though the mental misery of awakening to the reality of the West Mine was devastating, Walls was acutely conscious of his physical discomfort. Before lying down he had removed his boots. His toes were numb, as though frozen by the cold embrace of the coal. His head

ached; he had a stiff neck and his shoulders seemed laden down.

He rose and wandered down the road, threading his way amid scores of prostrate bodies. He had no idea how long he had been asleep. He was on edge to know the progress of the break-through plan.

"Anyone got the time?"

"Midday, if you're really interested!"

Walls squatted, fretting, beside his fellow worker.

"What news?"

The man turned his head and spat. "No bloody news at all."

"But . . . they said the road was open up the Dook, and that we'd get the all clear to start work."

"*They said!*" . . . Another spit, followed by "We haven't had word for hours."

Walls felt his empty stomach turn right over. Sharp sourness welled into his mouth. "Do you mean that something's gone wrong?"

"Just listen to *him*," jeered a man from the shadows. "Has any damn' thing gone *right*?"

There was an ugly edge to the ensuing laugh. Walls did not like it. Tempers were fraying. Nerves were beginning to show.

"Well bugger Andy Houston," said the man from the shadows. "I'm off to get a drink."

"But the water's rationed," he was reminded.

"Rationed? *That* muck! Fat bastards at the top won't go short of their ration . . ."

They arose, hefty men both, and nasty with anger. Suddenly they saw a fireman approach. Reconsidering they sat down again; furious still, but keeping complaints to a grumbling monotone.

Walls Walker moved away. He was no longer cold but prickled with unhealthy heat. He felt as sick as a dog.

Houston also had kept himself up to date about men's morale. Grousers were surprisingly few, compared with those

who never complained at all. Still, bad example was infectious.

"Can't really blame them either," he confided to Capstick. "Maybe *I'd* beef, if I wasn't the oversman."

"Hour after hour goes by," answered the other. "Not a single word . . . only that the gas is moving. It wouldn't fool a child."

Still moving! Houston had the same shrewd idea as Capstick as to what the euphemism concealed. Surely it would not be a bad thing if they were permitted to do *something*. Give them the feeling that all was not lost; keep their minds occupied; maintain their solidarity as a team. Why did not the Top allow them to start with the break-through. At least a beginning on that twenty-four-foot barrier? If they had to wait to dig until the gas was out they might be weak as rats, and about as useless. Already he knew from his own state how hunger, thirst, and sufficient time to think, could sap self-control.

The Surface called them on routine check. The bell merely tinkled.

"Ring us again," Houston said to the operator, *"there's something wrong with the bell."*

Again no proper ringing tone. The voice at the other end was indistinct, reception marred by a crackle.

Cautiously Houston waited until there was a clear space around the telephone. He did not want eavesdroppers to overhear. "Don't keep us waiting too long," he urged. *"I'm afraid that the phone is weakening."*

Drying her tears, Betty Walker put on a hat and coat and went over to see Jessie.

She thought: "It's even worse for her, with her so near her time. And then there's poor Pup. I'll need to call on him as well."

When she reached Connel Park Betty found her father-in-

law. He had come to comfort Jessie, but instead she was comforting *him*!

When he had left the bus and gone home to break the news to Mary, Pup had masked his heart-break. Contrived to bluff, summon up enough deceit to persuade his wife that the situation was not so bad as it might seem. But the effort had exhausted his reserves of self-control, leaving him incapable of further lies.

Arriving at Jessie's house he said : "There's no need to worry. They'll soon have Walls out, never fear." The brave words tailed off; the room began to wobble. Jessie brought him a chair, and he broke down.

As she looked at him now Betty was painfully reminded of the day when she first came to New Cumnock; English and a stranger to the coalfields. Also just a little worried about her reception. As soon as she set eyes upon her parents-in-law she had felt her fears dissolve. A gentleness and courtesy about them had perplexed her originally as she thought of the harsh, troubled background in which they struggled to feed their family. Later she came to realize the strength of their tenderness, forged by ordeals shared.

"Now," she thought, "the link has failed. Pup's too old to do the job he wants. Go in with the rescue brigades at Bank. All his life he's fought to help the family, but this time they won't let him try. He feels helpless, an onlooker. Forced to leave the fate of the boys in other hands."

Pup rose. "I'm sorry," he said simply. "I'm afraid I haven't been much use." He picked up his cap. "I'll away to the pit. There must be *something* they'll let me do."

By two o'clock the phone was fast deteriorating. They had to ring the surface six times before getting a reply. Houston summoned the firemen to see whether lamp batteries could be used to supplement the power. Results were discouraging.

"If things don't start to move soon," said Capstick, "we'll

lose all touch with the top. We won't know a damned thing about what's happening. Or what we're supposed to do."

Houston nodded. "You're dead right" (a pale grin) "though *dead* is maybe a wee bit premature!"

"Seriously though, I feel we should begin to work towards the barrier, even though we don't breach it till we know how things are outside. Main snag, I think, is that they're scared up top that some of the men might go a bit too far and break through. They're frightened they'll let in the gas and kill the damn' pack of us."

"What's your own view, Andy?"

Houston hesitated, then answered quietly, "I'd trust the men, they're not such bloody fools . . . not at this stage, anyway. Give them some action and a reason for it and they'll be all right. It's the waiting that's like to break them."

Capstick replied: "And you're bloody right at that!"

"Aye, even though we mustn't forget it's an overall picture that the powers-that-be are studying, I can't see much harm in *starting* to fight our way . . ."

"Just what do you plan to do?" asked Capstick.

The reply came crisply: "If we still haven't got permission an hour from now, I'll urge we start work immediately!" And he looked at his watch. . . .

7

"IN DEATH'S DARK VALE"

THEY'VE got the word to go. They've been on the phone to McCardel and he's ordered them to start digging!"

Down in Bank No. 6 they did not know the psychological set-up of the men in the West Mine. Nor had they been told of the surface officials' misgivings regarding Houston's request. They had both brains and hearts so drew their deductions from Area General Manager's laconic signal. He had "ordered" the entombed men to start breaking through. Things *must* be growing warm. The advance-retreat process of the anti-gas fight continued with little real progress, despite stupendous effort.

Queried a miner, simpler than his fellows, "But why should they tell them it's all right to start now? Why tell them to go ahead *now*, with things just as bad as ever?"

"Because they are getting weaker, man," replied his mate, "and are none the happier either. How'd *you* like to be caught and cornered inbye, with nothing to do but sit on your arse and scratch!"

McCardel's decision had been reached only after careful soul-searching. With the atmosphere on the Castle side deteriorating and the sludge threatening a fresh advance, it seemed sensible to reduce the width of the barrier so that the men could speed their escape directly the gas was cleared. On the other hand, as Houston shrewdly suspected, the AGM felt the gas would take longer to clear than originally believed. In which case the men might be provoked to rashness.

He reasoned that the narrower the wall of their prison the greater temptation to the prisoners. Fright over some imagined crisis in the Castle might cause a few of them suddenly to lose their heads. What if the diggers dug too far? In cracking through the last slim line of demarcation they might unleash upon their comrades and themselves the monstrous firedamp pent-up in No. 6. If only two or three Knockshinnoch men panicked tragedy could overwhelm the rest.

This, then was the grim Hobson's choice confronting the AGM. Danger in letting the men work, danger in inaction from having waited too long. His final decision had been strongly influenced by confidence in Houston's personality. Probably the deciding factor was the state of the telephone. Sensitive though McCardel might be to the gas menace, he was even more so to the possibility of the communications system's collapse. The telephone constituted his sole link with the trapped. It was weakening so rapidly that soon it must fail completely and with it all hope of a co-ordinated rescue plan. Best *start* the men under directions from the top!

So complex were the factors that when announcing his decision, McCardel carefully emphasized that the concession was conditional. The squads must work carefully; conform to official briefing. They must stop when told. Everything depended upon patience and Houston's ability to maintain command.

"A stickler for doing things tidy and official is our Andy Houston," Tom Walker remarked to his brother. "Might as well hand it to him. He knows what he wants. And gets it. Said he wouldn't budge an inch until he's got clearance and so on, yet all the time he's had the set-up planned."

The men felt much better now that they had a chance of coping with their crisis. It was the inaction which had been frightening. Work would be a tonic. Houston was relieved as any of them. Leadership was difficult to maintain when

restricted by orders to keep the men patiently waiting. It was good to perform a more positive role.

"We won't have much space in which to operate," he said. "So as not to fall over each other we will work in squads of four. Each squad to do a fifteen-minute stint. There'll be a fireman or shot-firer in charge of every group," he added. "And there'll be a movement programme to which each squad must conform to avoid delay in changing over."

He paused. "Well, there isn't much more to say except to gang warily and stick to instructions. So, if you've no questions, I'll call for volunteers . . ."

The response was fantastic. It surprised even Houston. There was not a man present who did not want to tackle the job. The first party commenced its downward march to the barrier within seconds of being briefed.

Their stint over, a group of rescue workers staggered out of the No. 6 mine mouth to blink bewilderly at daylight.

A hush fell upon the waiting crowd . . . a hush followed by a babble of questions. With orders to say nothing the men ignored them and pushed their way through to the improvised canteen. They were haggard beneath the black dust that clogged the pores of their skin. Short-tempered, too, because their exertions had not yielded all the hoped-for results. All very fine digging on the Castle side, but the gas was not shifting fast enough in Bank.

As one of the men moodily sucked down a mug full of sweet, warm, and welcome tea—better than any pint it was—he was approached by a prim-faced Salvation Army officer.

"We are all praying for you and for the men in the Castle."

"*That's* useful . . ." rejoined the rescue worker, unimpressed. Solemnly the Salvationist fumbled in his pocket.

"In the meanwhile," he said, "I would like you, as a favour, to take something to your friends."

"Tracts . . . bloody tracts," thought the worker, suddenly

angry. "Tracts, telling us to repent or else be damned. Why doesn't he go away—and take his bleeding tracts with him!"

The Salvationist proffered not a tract but a five-pound note.

"To help buy cigarettes," he explained with quaint awkwardness. "You'll be needing something to smoke after spending so long below."

It quite took the worker's breath away. As he said later: had the canteens served hard liquor he felt the "Army" would have ordered drinks all round . . .

Two hours had elapsed since the first squad trudged down the long slope to the Dook. As Walls said, those hours seemed to have passed as slowly as an entire day. In that interval forty men had taken their turn at the face; returned to the West Mine station to slump exhausted across the rails of the main haulage way. When they first arrived on the job they saw the thin middle seam grin from the craggy rock face like a row of bad teeth. Each group of cutters set to with enthusiasm, wishing the work-period longer. By the time they were off duty again they found they had had more than enough.

Houston's wisdom in insisting that each man's spell should not exceed fifteen minutes had been justified by the physical state of the men. They were surprised how they had weakened through hunger and thirst, suspense and shortage of air.

The squad now at work reacted as had their predecessors. For five minutes the men's pit-scarred bodies had bent and straightened with almost rhythmic precision. Nearing the end of the stint, the emptiness of their bellies told. As they cut into the leaf, easing to the side of the road the coal shaken free, their picks no longer bit so deeply; their shovels rang less loudly. They ached for relief.

"In . . . out . . . saliva and sweat . . . tug with the bright steel . . . wrench and pull free . . ."

There was a mute desperation about the half-naked men.

Almost they could *hear* the silence of the place, as little disturbed by the clamour of their tools as the darkness by the local radiance of their lamps. Bank No. 6 . . . the outer world . . . both seemed equally remote. Action, effort, and pain provided the temporary sum total of sensation. The slit-like aperture in which they slaved became, briefly, a planet on its own.

"Listen! *For God's sake, listen!*"

"Listen to what?"

The man, whose voice interrupted the dull reveries of the rest of the team, impatiently gestured.

"Shut up. Shut up, can't you. *Listen!*"

Work stopped. They crouched, immobile, hardly daring to breathe. Nearly a minute elapsed, then one of them swore. "We're wasting our time . . . listening to bloody nothing."

The others kept silent, peering at each other, seeking confirmation. Shadowed faces looked back at them. Expressionless beneath their masks of dust.

When they first heard the sound it came to them so faintly that each kept quiet, fearful lest he were mistaken. All at once a cry broke out.

"It's *Them*! It's *Them!*"

The brave words out, they again fell silent eagerly straining their ears. . . . Yes, there it was again! That Sound. No figment of imagination this time!

Tap . . . tap . . . tap . . .

It was quite plain. Somebody else's pick. Somebody else's shovel. Inching into the barrier, from somebody else's world.

Dave Park was not normally shy, but he felt so now. As he stepped from the car which had brought him speedily from Edinburgh to the pithead he was conscious of being moved and oddly humbled. It was as though being there today, so safe and "comfortable", was an affront to the patience, endurance and suffering of the generations who had toiled in the dark earth across the surface of which his car had travelled. This

was his home. Yet at the moment he felt half an alien, like a long-lost son returned to find the family plunged into mourning. One of his former neighbours spotted him.

"Hallo there, Davie. It's real good to see you."

Park tried to give a reassuring smile as he hurried forward, the crowd closing in behind him.

A chap he had, as a pit boy, regarded as being little short of God, slapped him on the shoulders, saying, with rough affection : "I knew that *you'd* be along to do what you damn' well could !"

There was a murmur of approval from those nearest. Park's embarrassment was replaced by relief. He knew the mine, he knew the men. He had specialized in rescue work and might still be of service. Only in the pit offices did his spirits receive a dampener.

"There are hundreds of men—literally hundreds—ready to work down there, Dave," a harassed official snapped. "And they don't need the Deputy Director to help with pick and shovel. No, there's not much you can do, man. Stick around, if you want to !"

Park's depression returned as he mooched about unemployed, between the Bank and the Castle. His inquiries were very much to the point : still he was perplexed by the circumstances from which the tragedy had arisen. Peat . . .? Surely they should have known ?

Eighty-thirty p.m. Houston stifled a yawn, then stared fascinated at the man before him. *Why, he was eating!* Houston's stomach rumbled in sympathy. He stared again. The fellow continued to chew.

"What have you got there, man ?" gasped Houston.

The miner did not reply immediately, his mouth being full. He savoured every morsel. After a last appreciative swallow, he answered :

"Orange peel." A slow grin spread over his face. "I'll tell

you now, I found it in the gutter. Just a few pieces of dried-up orange peel . . . but, Mister, did it taste good!"

Farther down the road Walls Walker saw a couple of his mates return from a forage in which they had secured a handful of crusts. Discarded by some bygone working party their find was, to say the least, old. So famished were they that the stale bread was manna. They scraped off the grey-green mould and softened the hardness by a dip into the scummy water. Walker's mates were proud as hell of their find, yet empty though he was, he did not envy them. Besides, he was hopeful now . . . hopeful of relief. The cutting parties were steadily inching their way through the barrier. He stretched himself, feeling the tiredness and pain ease from his sparse limbs. Home would be damn' wonderful!

One of the working squads returned to the station.

"All going well?" asked Houston.

"Just one thing bothering us," the fireman answered. "Seems as though the Bank men have been working in the wrong place. They're too far over to the left. Couldn't tell before, but now we're nearer we can sense the direction of the digging, as well as the sound of it. We're driving in parallel instead of towards each other."

"Oh, blast," Houston groused to himself. "Now here's more delay." Aloud he said: "I'll go down myself to make sure."

When the oversman reached the barrier he confirmed the squads' fears. His ear, long tuned to the tricks that noise could play in the noiseless earth, recorded the margin of error. About twenty feet too far over to the left.

He phoned his opinion to Bone. Communication difficulties were such that half an hour elapsed before the mistake was rectified.

Up at the pithead, Pup Walker wished for the thousandth time either that he was younger and fitter or less well known. He had found himself a job on the surface, but yearned the whole

time to go below. He volunteered only to be turned down. He
lodged an appeal. Still they said "no". They pointed out, quite
kindly but firmly, that this was a job for the young and for
people trained in rescue. Pup felt sure some of the strangers,
chaps from afar, lied over their ages and rescue work experi-
ence. Had not he the better right to risk his neck underground,
with Tom, Walls, and Alec helpless in the West Mine? With
James, Archie and Willie among the rescue teams in Bank?

As Pup thought of his sons he was consumed with anxiety.
He had never before suffered from acute frustration, but it was
crucifying him now.

Dave Park came and slapped him on the shoulder. "Cheer
up, Pup. We'll soon have them out."

"Are you sure of that, Dave?" Deputy Director of Labour
or not, the two were old friends.

Park sounded as optimistic as he could. "If you take my
advice you'll stop worrying. But you were never much of a
one for taking advice, were you, Pup? Remember that outing
on the Clyde?"

Pup smiled for the first time in twelve hours, thinking back
to the fun in the days before Dave became the high official.

"Aye. I was as sick as the devil," he confessed, "though you'd
warned me to be careful; said we'd run into rough weather."

"And yet," pursued Park relentlessly, "you took no notice.
You had two heavy meals and a skinful of beer as well, and
spent the rest of the day wondering what on earth had made
you sea-sick!"

They laughed together, remembering. "Take my word this
time, Pup. The boys will come through."

At the conference Park felt less sure. Work was going well
as regards the drive to the barrier, but the gas was still thick.

"A lot will depend on what happens when the borehole is
driven through," they told him. "Knockshinnoch is free of fire-
damp at the moment. If it stops that way, and *if* the Bank gas
lessens, and if the air blows from the Knockshinnoch side, we're

hoping that the men will be able to walk through. But the hope is slim. There'll be lots of snags yet."

Park wandered out. Though the night air was chill he found its touch welcome. Torn clouds whipped ragged streamers across the placid stars.

"Please God," he prayed, "that all will yet be well ... please God that the borehole goes through and the gas lifts from Bank."

A disturbing thought occurred. What would happen to the men's discipline if, having made their escape lane, they could not march out immediately. How would they feel down there if their hope was delayed?

"How will they hold together?" he asked himself, "if we disappoint them now?"

Although he hardly knew it, his stubborn will had decided the part he would play should things go as damnably wrong.

"If I were a blackbird I'd whistle and sing,
I'd follow the ship that my true love sails in."

Expanding his broad chest, Dave Jess was obliging his West Mine mates with a song.

"And in the top rigging I'd there build my nest,
And pillow my head on her lily-white breast."

There were derisive shouts, suggestive whistles; the audience was feeling fine. Each working squad returning from the barrier brought fresh encouragement. The gap was rapidly narrowing. The men in the Bank Mine could be heard very distinctively. No longer as a vague tapping but rhythmic hammering, their noise was growing louder. Gas or no gas, forecast the West Mine men, it would not be long now. Even Houston, who had thought so deeply on the complexities facing

the rescuers, shared the new sense of well-being. With amusement he watched the impromptu variety concert.

One man contributed an "Archie Andrews" act, with a light-weight colleague for dummy. Earlier there had been community singing. Better than Workers' Playtime!

Alternating hope and despair, thought the oversman. "My life; everyone's life . . . tears at one moment, laughter the next. Uncertainty in between." Twenty years earlier he had been mourning the death of his wife (his first wife) after a year of marriage. She had died giving birth to twins. One was stillborn; the other died six months later. Tears, bitter tears, he had shed. It had been a long time before he again could indulge in laughter.

> "So I'll cherish the old rugged Cross,
> Till my trophies at last I lay down;
> I will cling to the old rugged Cross,
> And exchange it some day for a crown."

As Houston left the concert party for telephoning he heard again the hymn refrain which, only a few hours earlier, had brought such dignity to the West Mine's ordeal. This time the words were echoed only in private by two diehard nonconformists. Laughter and tears, reflected the oversman, this time cynically. "Funny how our prayers seem reserved for the tear stage."

Half a dozen lights moving one behind the other and the sound of men's voices, excitedly raised, interrupted Houston's reveries. His mind jolted back to practical matters. A working party was returning from its stint.

"Soon be through now," the leader said. "The Bank team is operating only a few feet away."

"Good," answered Houston, "I'll get down there right away, ready for the time we drive the borehole."

He found the barrier men tense, and subdued. They listened

to the loud symphony of crunching, grinding steel against resistant rock and coal—it came from behind the face, but slaphappy optimism was dead. This was a critical stage, dramatic, far-reaching, as the working party men knew.

Their relief showed similar restraint. Even Jess—pick in hand, his concert role forgotten—had shed his ebullience. So much might depend upon the events of the next few minutes that light-heartedness seemed almost sacrilegeous. As the shifts changed Houston quickly recapped on McCardel's order.

Once the drill holed the barrier he would have to check up on the drift of the atmosphere : see whether the air blew towards Bank. If it did, things should be simple; quite soon they would be greeting the rescue team. Alternatively if it blew towards the Castle, bringing gas with it, they must plug the breach; re-seal themselves from the outer world. There would be no help for it. Impatiently, as the squad set to, he found himself fretting for the moment of decision.

Jess crawled to the face, then struck into it. The keen edge of the pick snarled into the coal. The rough wood helve was warm in the grip of his palms. His flung-back shoulders jolted against the cramping walls. Again he hit home—again and again. As he did so he felt hope return. Again he struck and again, cutting into the shelf as though it were a personal opponent.

Saliva formed, moistening his dry mouth; the blood surged through his bent head and then suddenly, surprisingly, he began to sing once more . . . sing raucously, boisterously : glad to be singing and fighting. "The Bonnie Lass of Ballochmyle" (profane version) filled the dark working-place; a ballad bawled to the harsh accompaniment of a swinging pick clanging against yielding coal. "The Bonnie Lass", so often sung with his brother Dan. On the journey to Wales for the International : at the bar on a Saturday night. He was thinking of Dan, as he struck again and again !

.

Hard-eyed above their breathing apparatus the Bank party men ceased work. Squatting back on their haunches they stared silently at the curve of the rough-hewn coal before them: as if, by mere looking, they could pierce its mystery and see beyond to the entombed Knockshinnoch men. In this too-close confinement, with the swirling invisible gas around their heavily burdened heads, they were at last approaching the barrier's crumbling end. The near-crisis had a numbing effect.

The sound of steel behind the barrier rose to shrill intensity —the pick had been replaced by a hand-drill to drive the slim bore. Before their frowning gaze the coal began to flake, to bubble outwards from the Castle face. A cloud of dust shot up, sweeping like thin smoke above the bright glare of helmet lights. A rush of air, a release of pressure as the drill came through and a lump of coal was thrown at them like a cork from a bottle.

The men waited a moment, tense, apprehensive. Almost motionless, crouched in the Bank darkness as though in silent prayer. Then slapping over their equipment and tingling on their exposed faces, the draught. Its touch was clammy, but it had force behind it. And it was coming from Knock-shinnoch. Someone cheered.

A minute later one of the men seemed to go crazy.

"Listen to that!" he shouted. "Listen!—'The Bonnie Lass'. 'The Bonnie Lass of Ballochmyle.'" He grasped the man nearest to him by the sleeve. "'The Bonnie Lass' . . . don't you know who's singing it? *My brother Dave!*"

Houston was not normally demonstrative. Hastening back to the West Mine to give the men the news, he found that for the second time in twenty-six hours his eyes filled with tears. Such emotion slightly scandalized him. It was hard to conceal. Almost he was grateful for the length of the journey since it gave him time for composure.

Every man was astir in the crowd that greeted him. He

made a wisecrack. "If it's drink you're wanting," he told a thirsty character, "you'll get whisky by the bucket in a few hours from now."

Carried away by this thought someone yelled, "Good old Andy."

Another worker grumbled. "Hours! Did you say *hours?* My God, surely it's not going to take all that time?"

Uneasy again, Houston hesitated. Sharply and with a certain awkwardness he answered that some people were never satisfied.

He telephoned the surface.

They replied: "Fine."

Houston found the comment inadequate.

"It's a great moment down here! A great moment for us all!"

"It must be that," was the quiet reply.

Again he was aware of the hesitation—embarrassment even. Then came the warning.

"Don't let the men stray. Keep them together as before. We've still got a bit of work to do. We're still having trouble with the gas."

"I see . . ." answered Houston slowly. "Well, of course, we knew it would take a time to clear."

As if detecting the new flatness in his voice, the Surface suddenly perked up. "Anyway, it's splendid news about the break-through. You can go ahead and enlarge the hole. In fact, that'll be first priority. We're sending a rescue team. All going well, they should be able to get right up to the station."

Before hastening again to the barrier Houston told the men: "I'll be back in twenty minutes."

He was to be absent longer than he thought.

Up top, the shrill blast of the colliery hooter cut into the thoughts of Paton's men, emptied canteens, sent a shivering

shock-wave of hope through the haggard-faced crowds keeping vigil at the wind-swept pithead.

· · · · ·

For a second after the last sobbing note had died away there was almost complete silence. Then emotion broke loose. A shining-eyed girl dropped to her knees to pray, crying, "They're saved! They're saved!" An old woman threw her arms around a muck-covered rescue worker, pressing her face to his chest. Despite his ox-like physique a pit-scarred miner whimpered like a baby.

When Lord Balfour and Will Pearson of the NUM, accompanied by McCardel, emerged from headquarters, they were greeted by a wild cheer. Cheers also followed their announcement of the break-through. The remainder of their joint statement brought more thoughtful reaction. The gas in the Bank Mine still had to be dispersed. It might be a fair time before the men could move out. To Pup Walker and other shrewd veterans it was plain that much still could go wrong.

Among those whom the disaster brought hastening to Knockshinnoch were two young Salvationists, Arthur Morris and his financée Iris Wyllie. Strangers to the district they had come from Saltcoats to help in the Bank canteen. At the end of the official communiqué they joined their comrades in leading the crowd to sing the 23rd Psalm:

> "Yea, though I walk in death's dark vale,
> Yet will I fear no ill:
> For thou art with me . . ."

To those who knew Arthur and Iris the majestic refrain, rising so fervently into the blustering night, was to have a peculiar, personal poignancy. These dedicated young people were to fall victims to Knockshinnoch's tragedy.

On Sunday morning, their Christian duty done, they were to be killed in a car crash on their journey home.

"Yea, though I walk in death's dark vale . . ."

Arthur and Iris were not alone in their sacrifice. As the psalm finished, they returned to the work which was to occupy the thirty-six hours remaining to them of life.

New Cumnock was already mourning the passing of Hugh Blackwood. One of the earliest volunteers at the crater, Blackwood also was on the way home when death struck. Complaining of feeling ill, he collapsed in Glenafton Road. Though a doctor was called, it was too late.

Mrs. Blackwood was first of the wives to hear that her man would not return.

The Gas . . . Hell, how it lingered! The hooters had signalled a partial break-through—that was to say the breaking of the coal and stone barrier. Down in Bank No. 6 firedamp still lay heavy across the escape road. Muscle and sweat alone could not clear this blanket of death.

Stupendous efforts at dispersal were made. Stoppings were built along the roads, sited to trap the surface air currents, to deflect them into the old workings. A new fan was installed. A group of rescue workers, progressing beyond the point where the escape tunnel had been driven to Knockshinnoch, erected a screen to seal off additional gas concentrations detected in the innermost recesses. Yet despite the expert planning and hard manual labour Alex Stewart, in charge of the fans during Mac-Donald's temporary absence on the surface, became increasingly pessimistic.

"There's no use deluding ourselves," he said. "Our progress is too slow."

"But surely, Alex, things aren't so bad as they were?" demured a colleague. "There'll be food and drink to keep the men going once the team gets through. This firedamp's a devil, but they can wait a bit longer . . ."

"Can they? I *wonder*."

"Houston's been away for a hell of a time," someone complained, putting into words what others thought. There was mumbled assent. A check-up revealed that two firemen also were missing.

"They've gone off to the hole to look for Houston," volunteered an elderly miner.

"Well, what do you make of that . . . ?"

The miner groped in the pocket of his jacket, produced a screwed-up piece of paper, which he put up his nose and sneezed extravagantly. "If you ask me, things aren't so good as they seem."

"*Balls!* You wouldn't talk that way if you weren't down to your last pinch !"

The snuff-taker shrugged. "Maybe not, but I think you'll find I'm right. There'll be no simple walk-out from this place . . . Something's gone wrong at the barrier, or we'd have heard sooner."

"What'll you bet?"

A pause for thought, then : "Oh, just the price of a pinch, no more than that. If I lose, it won't break me. Both of us may be past caring if I win. . . ."

On his return to the working party Houston had hoped to start upon the job of enlarging the six-inch hole so as to bring the rescue teams through. But they, with ill-omened prudence, gave priority to supplies. Bottles of water, flasks of tea, packets of sandwiches had to be taken through before the Castle party could resume digging. In the very last lap the rescue teams had a casualty. The breathing apparatus of one of them developed a fault. His mates had to drag him back to safety.

Such manœuvres took time. When Houston had the long-anticipated pleasure of greeting the incoming team, those twenty minutes of anticipation had stretched to more than an hour. The most unpleasant setback arose when he started

leading the party up the slope of the Waterhead Dook. The circumstances which caused this rebuff would have made less resolute hearts despair.

Anderson and Stewart, the two firemen who set out to contact Houston, reached the top of the Dook, pausing to carry out a routine test for gas. They had done this at regular intervals along the route to the barrier. So far results had been negative. The "missing" oversman had conducted similar tests. So had the men in charge of the working parties. The Knockshinnoch side had been completely free of gas—*until now.*

Silently the firemen watched the warning flicker. One returned for Capstick.

"We'd best get a brattice up," he said.

"And do it on our own. No sense in spreading the news."

As they erected the tarred canvas panel to shield the West Mine from the gas, the trio thought of Andrew Houston. They feared for him. What if his delay were caused by this fresh emergence of the enemy? Maybe there was a bigger concentration at the barrier or the working party had been overwhelmed? Then it was they saw the advancing lights; the best of all sights.

"Thank Christ you're back," shouted Capstick. "We thought you'd had it!"

The black silhouettes of the rescue men, pressing close behind Houston, held the gaze. It was like a miracle that these were figures of flesh and blood, not mere ghosts. Houston's questioning cut into this daydream and Capstick returned abruptly to sombre facts.

"What's all the fuss about?" asked the oversman, scowling at the brattice.

"No *fuss*," answered Capstick tersely. *"Gas!"*

Would there be an end to disappointments? Houston realized that "end" might have a sinister implication! He spoke hurriedly :

"No need to tell you to keep your mouths shut. It'll be bad enough telling them about the gas in No. 6 without letting them know we've a similar problem on our doorstep."

One step up, one step down; one thing right, another wrong. The more you knew about it all, the worse it seemed. Houston left the firemen to continue their defence plan. He brought the rescue team into the West Mine station. Still brooding over the new, threatening turn of events, he again envied the ignorant ones.

The West Mine men almost went mad with excitement as the rescue team marched into the haulage-way. The cheer echoing through the dark tunnel would have done credit to a cup final. Nerves, long under strain, snapped under the suddenness of relief. It was a back-slapping hand-shaking, semi-delirious moment. Some of the men grabbed their powder tins and tools, expecting immediate departure.

"We're all ready to quit," bawled one of them. "Just show us the way."

It almost broke Houston's heart to undeceive them.

Beyond the barrier, way over in No. 6, there was a subtle change in the feel of the air emanating from Knockshinnoch. Puzzled, those at the outposts sensed this but were at a loss for the cause. Only momentarily, however. It was soon obvious that *the draught was decreasing.*

Urgently they reported this finding to base. The atmosphere underwent a further change. *The draught was changing direction; commencing to blow from Bank!*

Shocked officials began to realize what was happening. The original rush of air from the Castle side had been but the quick release of an atmospheric pocket pressed on to the barrier by the sludge. The initial impact spent, pressures were equalized. The air from Bank was thrusting through the rescue hole, and wafting gas with it.

8

NEAR BREAKING POINT

I T'S just a temporary set-back," said the Voice over the
phone. "We'll soon have you out."

Lightly as he could Houston replied, "I hope so, sir."

It had been cruel telling the men that release must be post-
poned. The sight of the team had swept caution from their
minds. His previous warnings of gas needing time to clear were
forgotten. Yet despite the intensity of disappointment the
crowd took the news better than he hoped. The food and drink
had disappeared within seconds of arrival. Fortified, they
agreed to be patient. Surely, they argued, the worst of the
ordeal was over.

Proud of them, Houston was embarrassed by their con-
fidence in him. They took his words for gospel. All the while
he partly deceiving them. *He* knew that future prospects were
likely to be bleak. His duty was not to tell the others.

The gas barrier might be dwindling slightly in No. 6. The
firemen's discovery in the Dook meant that the general danger
area was increasing. To broadcast this new development would
be stupid. Yet the deception troubled him.

His report to the surface was discreet. He waited until the
men were occupied with the rescue team and the vicinity of the
phone clear. He now knew that gas-laden air was seeping in
from No. 6. Suppose they had to re-block the hole? What
price morale then?

There was a sudden movement amongst the crowd in the roadway. Rescue men began to form up.

The team's captain addressed the waiting miners. "I'm sorry about this. It's lousy having to leave you here, but it's time for us to go." He spoke with averted face. Afraid to meet the oversman's gaze.

"Hell, he's fed up too," thought Houston sympathetically. "He can pat himself on the back for a job well done. He gets through, brings us food, is hailed as a ruddy saviour, then comes the anti-climax. Despite all that he has done, he can't do what he wants. He can't take us with him!"

"I quite understand," he said aloud. "Thanks for getting through."

A youngster cut in. *"Understand?* Well, I'm damned if I do."

Houston turned on him furiously. "Well, understand this. You can't move and you won't move until we get the all clear. These men have already used up most of their oxygen. They've done all they can. Now they're ordered to go back."

"But . . ."

"No *but* about it," snapped Houston. "That gas is a killer. You can't just walk out."

The lad shuffled off. The incident was closed.

"Anyway, Houston," the captain said quietly, "you'll be seeing more of us soon. Or at least you'll be seeing the others. The place is swarming with rescue brigades. So just continue to be patient. We'll celebrate together, crack a bottle or two when you reach the top."

"Aye, we will that, God willing."

They shook hands. The captain rejoined the team. For a few moments longer the rescue workers lingered to adjust their breathing apparatus and collect their gear. In single file they then tramped away.

"Well," said Walls Walker. "It was nice while it lasted."

Flatly, silently, the West Mine men saw the bobbing lights disappear, one by one.

For a practical administrator and highly skilled technician David Park had a startlingly vivid imagination. There were times when he considered it a liability. This was one of them.

Dazzled by the glare of the naked electric light bulbs his eyes blinked blearily at the plan of the workings, spread out on the HQ table. His ears were tuned to the somewhat strained voices of the grouped officials, but his mind roamed far beyond the stuffy little office. In imagination he sniffed the sourness of the Door : felt the claustrophobic sensation of being trapped in the West Mine. He sensed, too, the reproach of the men below. The peril, frustration, and bitterness of them all was on his conscience, compelling him to act.

"The men have been grand," he said. "A lot better than you, or me, or anyone else would be. But if we don't get some good news to them soon or do something drastic to bolster up morale, your guess is as good as mine how long their patience will last."

Glumly a colleague nodded. "What else can we do? They'll find us out quickly enough if we tell them a pack of lies."

"Lies? I wouldn't be so damn' stupid."

"Well then . . ."

"I think there will be trouble," Park insisted. "The men are under the most terrific strain. They've already had their hopes raised and dashed a dozen times. There must be a breaking point. Houston's done marvels, but he can't hold them on his own for ever. They're not robots."

"Hell, David, don't we all *know*?"

Restive, the other glanced at him half angrily. "What's on your mind?"

"So this is it," thought Park, "the moment you knew must come and dreaded."

Aloud he said : "Just this. The time has arrived for someone

to go through the barrier, see the men, and explain the set-up on the spot!"

"That's what the rescue team has done already."

"Agreed," answered Park, "but now we must do more." He paused, adding firmly, "If we're really going to convince the men that we are doing our best . . . if they're really going to believe that we'll stop at nothing to save them . . . then someone must go through who's prepared to stay for as long as is humanly possible. Someone who isn't a rescue worker, expected to risk his neck, but associated with the management. An official."

"Who, for instance?"

"Me."

"But, David . . ."

"It's no use. I've made up my mind. I'm going down. They'll listen to me. I know these men. Don't forget I worked with them."

Rumours circulated at the pithead. Some were true or based upon truth, some were false. All were depressing. A fall from the roof had blocked one of the roadways of the Bank Mine. The gas-laden air, pumped back by the fans, was recoiling at strength against the escape hole. Ambulance drivers, alerted to take the men to hospital when the barrier was first breached, had been stood down. The sludge at the rear of the West Mine had resumed its advance.

Alarmed by the passage of time since the announcement of the rescue team's contact, relatives were only partly reassured by official explanations. Little could be done to relieve anxiety. Only to contradict the more flagrant rumours and reiterate that no effort was being spared to bring out the men.

"Gas . . . always they blame the bloody gas," growled one embittered spectator. "Makes you wonder if they're *trying*!"

"Shut your mouth, you!" swore the man beside him. "You don't know what they're up against."

Despite acute concern the majority of people at the colliery did not blame officialdom for the agonizing delay. The very keenness of the authorities increased still further nagging fears that things were going badly. Fans, switchgear, baulks of timber by the score, rescue brigades, ambulance teams, cranes and bulldozers for the crater . . . so much effort expended upon the rescue plan that it seemed incredible there was so little reward.

It was 3 a.m. on Saturday by then, and still no word. Those waiting shivered, trying to read the expressions of the men coming off shift from the Bank Mine. Heavy-browed, almost silent, tired : this was no victorious army.

A young wife, her sleep-hungry face tormented beneath her headscarf, turned to her mother. The girl said, "No need to ask. You can see by their faces they've had no luck."

Her mother did not answer, only linked arms. Thus they stood, two waiting women, the wind gnawing at their cheeks and setting the little ballerinas on the young wife's scarf twisting and turning in a dance macabre.

What would dawn bring? Hope or despair? Stewart for one would have found an answer hard.

Disgusted at the slow way the fans were extracting the firedamp, just before midnight he decided to make a drastic change in the dispersal effort. Instead of exhausting the gas he would seek to dilute it with a mixture of oxygen to create a breathable atmosphere.

The changeover took time. The West Mine men again had to be urged to patience.

"And if *this* should fail," Stewart said to a colleague, as the fans again began to pulse, "there'll be only one trick left."

"And that is?"

"Whether we like it or not we'll have to write off every damn' plan we've made till now as a ruddy waste of time. And

take the awful, impossible risk of trying to bring the men out in breathing apparatus."

"Breathing apparatus! By untrained men! Weight forty pounds and with seven separate valves to fiddle with . . ."

"Agreed, agreed," answered Stewart wearily. "At a pinch there might be a chance with the Salvus. Lighter, simpler to operate . . ." He hesitated then added thoughtfully : " Wonder if we couldn't get some Salvus sets from somewhere? Get them to the men and let 'em walk out wearing them. Wonder if that's a working alternative?"

"But Alex, the Salvus is Navy. This isn't a blasted submarine."

Stewart said, "It's getting to feel like one. H.M.S. *Thetis!*"

"And think of the men . . . the slightest mistake, a moment's panic and they'll be so many stiffs."

Stewart answered : "They'll be stiffs in any case if we don't try something."

Breathing apparatus. Stewart was not the first official to consider the frightful possibility of the fans failing. Nor was he first to ponder on the possible alternative method of effecting a withdrawal of the trapped men.

Somewhat vaguely it had already been suggested that should the gas not clear the men might be fitted with self-contained breathing sets. The perils of this project sickened those considering it. The Proto model was hardy, but over-complicated. Impossible to operate without intensive practice. The Salvus was a Navy job for underwater work. True a few collieries were equipped with it, but only so for fire services working in thick smoke whilst tackling surface outbreaks. The Salvus never had been authorized for underground, let alone full-scale battle against gas. A battle in which 116 completely untrained men, all suffering strain, sleeplessness and hunger would have to master the apparatus's technique in about an

hour. And use it immediately to penetrate a poison belt half a mile long.

Like Stewart, Park had a good word for the Salvus, but was as fully alive to the hazards of using it in an operation of such magnitude. Only the greatest extremity could justify such a risk. Conditions were too unorthodox.

He was astonished when he heard that authorities had arranged transportation of a number of sets to the Bank Mine. Both astonished and apprehensive. Though the measure was described as "limited" and "precautionary", that it had been introduced at all was symptomatic of waning confidence in gas-dispersal.

Still Park's determination to enter the West Mine did not falter. If anything, the apparent worsening of the situation gave urgency to his plan. Not everyone agreed about its wisdom.

"The whole idea's crazy," said the senior official. "Park must be crazy to dare to put up such a suggestion."

His colleague was not sure. "Crazy or not, he's willing to stake his neck on it."

"He'll hinder more than help," went on the senior official, "and he bloody well ought to know it. The rescue teams won't want to take a passenger."

"Passenger?" The other's expression hardened. "You can't class Park as that. He used to be captain of the rescue brigade here."

"Aye, but that's years ago. A man can't keep young for ever."

It was very difficult for Park to restrain his anger as he listened to the objections of critics of his scheme. The target was important : passion must not intervene.

"I keep myself pretty fit," he answered levelly, "despite the desk job and middle-age spread. I know all there is to know about the Proto. I won't be asking for anything!"

"But put yourself in my place," said his adversary. "Would *you* feel happy about staking another life?"

Momentarily Park softened. In a similar position he, too, would have had doubts. This probing of pros and cons was a duty, also a matter of conscience. But—time was pressing. His mind was resolved. This was one of those things a man just had to do.

He decided to put his case to higher authority.

See Lord Balfour.

In the Knockshinnoch West Mine the elation over the rescue team's arrival had vanished dramatically with its departure. The latest delay in gas-clearance had sobered everybody.

True there was that stubborn code which they had observed from the moment of disaster. It had bound them together through twenty-eight hours of harrowing imaginings and repeated reverses. It still bonded the majority of men. A few, such as the Walker brothers, were reserved. They masked their fears with a studied pretence of normality. Others jested of their plight, finding solace in false laughter. For all this Houston was aware of increasingly uneasy feelings. He was human. Fear was no stranger.

He had broadcast the news of changeover in the tactical handling of the fans. Demanded further patience. The oversman's personal acceptance that all still was "according to plan" almost had given way to the same despondency as the men's. Every time he addressed them it was to announce a fresh set-back. A minority of dissenters were becoming increasingly vocal. A further hold-up could bring about an ugly situation.

A man rose and approached the telephone. "Why don't you tell 'em not to spare their sweat!"

"Tell who?"

"Those bastards in No. 6."

Anger swept through Houston. His voice sharpened with

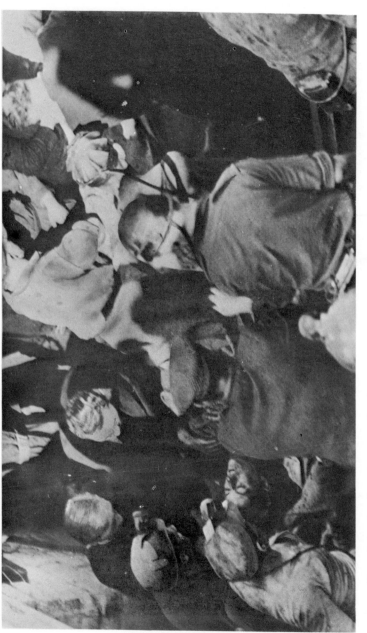

Out of the depths, after an epic of cool courage, comes the first of the freed; stretcher-borne.

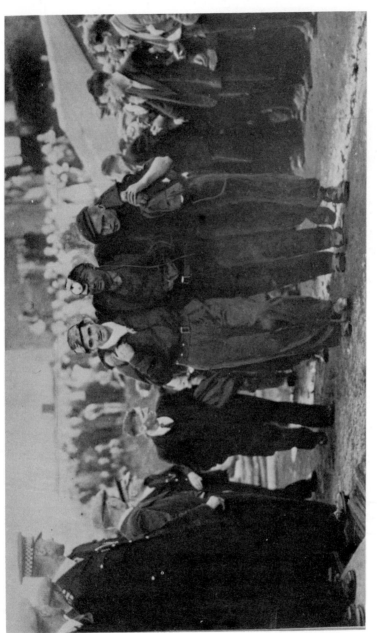

Shoulders to lean upon, fresh air to breathe—and the light of the day to blink at, in stunned gratitude and relief. The most fantastic rescue operation in mining history draws to its close.

contempt. "Only an ungrateful fool would talk like that! You ought to be ashamed."

"Always the bosses' man," the miner sneered. "Faithful to the bloody last."

"Call *me* what you bloody well like," snapped back Houston, "but leave the rescue teams out of it. Maybe you'll apologize to them—when they've saved your worthless neck."

After the man had slouched off, Houston thought, "he's not the only one to wish for action. Wonder how he'd feel if he knew the gas was so close?" Houston himself felt pretty bad.

Visiting the main body of survivors ten minutes later, he met Juan Carracedo and the dark mood lightened.

Juan had descended upon Scotland during World War One, when mining labour was so short that even the New Cumnock coalfield (politically radical, racially conservative) had accepted, with misgivings, imported foreign workers. Most of the Spaniard's experience had been unhappy. Many had died during the influenza epidemic and fled the climate as soon as their contract finished. A few of the dark-skinned strangers remained to take root.

Sixty-three, known to his mates as Wang, Juan Carracedo was as "accepted" locally as any Ayrshire man. His vivacity remained "foreign" as the Spanish sunshine. Hands, eyes, and grin were used expansively; vivid gesticulation accompanied every word.

"Jesu Chreest," he cried, seeing the oversman. "Jesu Chreest, but I have had great misfortune!"

"It'll work out, it'll work out," replied Houston, mechanically performing his patter. "We'll all be okay soon. You need have no doubt of it."

"But not for the St. Leger, Meester Houston," came the astonishing reply.

"St. Leger?"

"Yes, she is today, and here am I, losing a fortune in this ruddy black hole."

Houston answered the laughter in the Spaniard's voice. "Never mind, Wang. No horse is a cert. You may find it's cheaper to stay here a bit longer."

Someone wisecracked from the darkness, "Place your bet through the pit phone."

"And tell 'em I'll guarantee the stakes," suggested someone else.

"Chreest," replied the Spaniard quickly, "I don't think there are many bookies who would give us credit now!"

"Good old Wang," thought Houston. "Sixty-three if he's a day, yet as pawky as a schoolboy."

A few minutes later a fireman drew Houston aside, dissipating his pleasure.

"Two or three bloody lunatics are talking of making a break for it."

"Of *what*?"

"Of making a break for it."

"God! They won't get twelve yards!"

"I've shut the fools up for now," the fireman continued, "but they won't stay quiet for ever."

Grimly Houston returned to the telephone, to report this development.

"Houston and I," said Park, "are very old friends. We know each other's mind. We could work together very well."

He glanced at Balfour to study the effect. His lordship's eyes were twinkling.

"I think," Park reflected hopefully, "that he's actually on my side."

There was still intelligent opposition. Desperately he sought calmness and detachment. He tried to make his enthusiasm appear objective.

He considered himself sufficiently high-up for the men to feel that he would not have been allowed to join them if the

situation were critical. But his own life was not indispensable
—not when measured against the lives of the rest.

Again he glanced at Balfour upon whom he believed he was
making a favourable impression. He was still in doubt about
the others.

"Snag is," one of them said, "that I still can't see that the
effect of your going down will be worth the risk you'll be
taking."

Park decided to play his trump card. Decisions were
balanced upon a razor-edge; opinions wavered. A slight push
either way? He decided to push.

"Another point is that I'm very well used to the Salvus. I'd
lots of experience with it when I was sent to County Durham."

The push registered.

"We used it for fire-fighting," he went on with increased
confidence. "I hear that it may come in handy down below,
now that the gas isn't clearing."

The telephone bell interrupted them. Message from the
West Mine: "The men are increasingly restive."

"I'd very much like to go," Park urged.

The renewed discussion was confused.

"Well, it's unorthodox," said someone dubiously. "But so's
the disaster itself. After all, nothing that's happened here is
according to the Book."

Park looked again at Balfour, who nodded agreement.

"Right then," said McCardel. You'll have a medical test,
and then, if you still want to, you can go."

9

THE "BIG BUG" TAKES A CHANCE

ANDREW HOUSTON nearly lost his temper. Five of the impatient minority crowded round the phone, urging complaint about the slowness of the rescue effort. He covered the mouthpiece with his hand, shouting to them to "Stand clear, damn you. I can't hear a word they're saying." In the grudging pause that followed he learned the latest from the surface and even his firm spirit faltered. The gassed area had widened. They had screened the rescue hole. Knockshinnoch was again on its own.

Houston stood there bemused and unhappy. This unpleasant news disposed of, he was exhorted to impress upon the men the necessity for calm. The speaker seemed as remote in understanding as he was in distance.

"Calm? Good God, they'd kept calm for long enough already! Were they trying to be an advice bureau at the Top?"

"Tell us, Houston . . . what are they saying?"

Lit by the helmet light the oversman's face for once had betrayed his feelings to an audience quick to notice.

"Shut up," he hissed, annoyance flaring again. This time he could not prevent one of the bitter few shouting into the telephone.

"Get off your backsides, you bastards! Get off your backsides and get us out of here."

.

"That settles it, I think," said Park. "I'm going down right now."

The doctor passed him as fit and he donned his working rig. The clamour from the West Mine and the shout that had startled the officials before Houston managed to hang up, was startling proof that his journey was really necessary.

They said to him: "We've decided to keep quiet about what you intend to do. Don't want to start false hopes in case you can't get through."

He nodded. "Okay . . . but it won't be long before you hear from me over the West Mine telephone!"

They wished him good-bye and he heard someone say: "Well, if the worst comes to the worst I don't suppose one more will make much difference."

The comment brought a wry smile to Park's lips.

As he went towards the mine-mouth the Deputy Director began to feel quite good. Confined to HQ he was like a cat on hot bricks. The contrast between his safety and danger of the men below humiliated. He felt an almost personal blame. Hence his relief at action. Perhaps the term exhilaration would be nearer the mark. He knew the feeling would not last.

It was one thing to undertake the job you felt must be done. Another to imagine that you would enjoy it.

"For Christ's sake get a move on. We're not waiting here for ever!"

The bellow came from an impatient rescue man. The Deputy Director of Labour, glad that the words were not aimed at himself, heaved his stocky frame into one of the coal hutches that, hitched together improvised a train outside the mouth of No. 6.

"Hurry up. Put a jerk in it!"

The rescue man again! Half a dozen shapeless figures stumbled from the darkness. Park settled, anxious as any for the journey to begin.

Knees hunched beneath chin, spine wedged against slimy

steel: almost it was like old times . . . almost but not quite. To his left gangs of labourers were busy heaping a mass of pit-props and chocks—reserve timber for the repair teams. Busy, too, upon the crumbling sides and roof of the old workings below. To his right mustered a group of onlookers, many of them relatives of the Knockshinnoch men. They stood dispirited and silent, regardless of the wind's bite from over the shadowy hills.

"Ready now," yelled a man in the hutch ahead. A half-smoked cigarette was thrown aside, its red tip glowed briefly as a meteor before hitting the puddled earth. Park glanced up at the driving sky and wondered if he ever would see it again. A jolt jarred his backside, cold in the mess of rain-sodden coal. The train was moving.

"Next stop King's Cross," someone shouted. This nervous attempt at humour was lost in the clamour of the wheels as the dark mouth of the drift closed round them and the breath from the depths began to reek vilely in their nostrils. This was the de luxe part of the trip; this noisy ride along the rusted tracks dipping to the old workings seven hundred feet below. For Park the real trial would begin upon debarkation for a mile's sweating scramble to the Fresh Air Base. Self-imposed and painful pilgrimage to the fringe of the lethal gas. And after that . . .? The Unknown!

They were so busy in Wilson's field that there hardly was time to curse the weather. Steel tubs, bogies, bag after bag of cement: Paton's conveyor, improvised so speedily, whisked them towards the crater at a startling rate. Bulldozers, rocking and roaring across the turf, blazed a trail for heavy vehicles from the main Afton Road. Giant cranes, mounted on tractors, slung ton-weight timber baulks into the morass around the hole's wide rim. Yet despite such impressive activity the surface workers were mocked by nature. The crater's appetite remained insatiable.

The "good agricultural land" that the officials had so confidently traversed less than a fortnight earlier was a treacherous
bog. Just before sunset half a dozen tree trunks had been hurled
into the hole. They were now invisible. Flood water flowed
down the hillside from the swollen stream; the Afton in full
spate crept onwards through sodden soil. The fire service
auxiliary pumps and the ditches upon which hundreds laboured
remained inadequate for the volume. Only part of the flow
was divertable from the field. The rest converged upon the
crater. Seeping through its sides it threatened, by the sheer
weight of fresh falls, to push the sludge on and over the trapped
men.

In the West Mine the keen-eared received fresh evidence of
rear enemy menace. It came in a series of restless whispers,
intermittent, widely spaced but menacing and striking chill.

One youngster awoke groaning.

"The porridge . . . the porridge . . . it's closing in on me! I
can't swim through it, man. I don't know how to!"

Realizing where he was, he sat up and apologized. "You
must think me a fool, but I had such a bloody nightmare."

"Quit your blatherin, son. You're not the only one."

David Park, encumbered by safety lamp, batteries and heavy
duty apparatus, was two-thirds of the way to Fresh Air Base.
He reflected: "Maybe that chap in the office was right. I'm
not so young as I used to be."

Had been a time when the forty-pound Proto felt light as
his dungarees. His helmet had seemed natural as a cap. The
past ten years had made a difference. His breathing apparatus
was being carried for him to the fringe of the danger zone but
already he was beginning to tire. This fact momentarily
alarmed him, lest he had over-estimated his stamina and might
handicap the men he wished to help. True he had endured a
lot of mental tension before starting. Greater tension was to
come. Park did not pretend otherwise. "Hell", he thought

suddenly, "if I think like this much longer I'll be my own grandfather!" He eased his broad shoulders. He would soon be acclimatized.

He heard men's voices and hammering. Around the bend was an oasis of light. A squad was providing extra roof support. Someone talked about a near-by fall. No one spoke to Park as head bent and ankles aching, he trudged on towards his objective.

An outcoming team, slow-moving men in single file, approached. Park was briefly tempted to question them. Seeing their weariness he refrained.

Once Park had marvelled at the speed of modern travel: Prestwick to New York in fourteen hours; London to Sydney in well under a week.

"Incredible," he had said, "that a man's environment could change so completely in so short a time." Ankle-sore now and with mud oozing under the tongue of his boots, he felt the mine's cold through the thickness of his socks. His was a change few globe trotters could equal. In a clock's time the London conference was less than seventy-two hours behind him! In sheer contrast of conditions, however, it was a world away. Or maybe an *eternity*? Park found himself grinning at his own grim joke.

When he arrived at the Fresh Air Base he felt fit as at the start. Too old at forty-five? Not bloody likely! It was just a question of becoming acclimatized.

In this intensely busy place the Deputy Director of Labour found no welcome on the mat. As a person they were pleased to see him but dismayed at the reason for his visit.

"You're too late for the West Mine," Stewart said. "We've blocked the rescue hole."

"You buggers make my flesh creep. You're content, the lot of you, to die like rats in a trap!"

"Aw, shut your mouth. You've got to die somewhere."

Tom Walker butted into the argument. "Wish the two of you would take your quarrel somewhere else."

The first speaker's oratory was in spate. "Thirty-two hours we've spent here, waiting for them to do something. And what *have* they done? Nothing! All the wonderful resources in the world must be on tap. Give them a few feet of gas and they as good as throw in the sponge. They're doing sweet FA."

"You must be pretty scared to go on talking that way," sneered his opponent.

"Scared? I'm just bloody angry that's all! It's you folk who are the scared ones. So scared of the bosses even now that you won't do a thing without orders!"

Walker intervened. "But they must know what's best up there. I don't care what you say. They'll get us out all right, if we don't make fools of ourselves."

"*They! Them!* Our f——ing guardian angels!" The miner spat, and wandered off to the West Mine's smelliest corner of convenience.

"He's scared stiff," said the other man.

Walker answered: "Aren't we all?"

He sought his couch between the tracks of the haulage way, at a loss to account for the repeated delay. "*They, Them—* our f——ing guardian angels!"

"*You've blocked the rescue hole?*" Park felt despair clutch at him. He parried it at once. "Well, that shouldn't make much difference. It'll have to be opened some time!"

But the local Inspector of Mines was more discouraging than Stewart.

"I'm sorry, but you can't go through. Even when we send in another team I won't be able to sanction your journey."

"*Why not?*" Park's earlier tiredness disappeared.

"You know the answer as well as I do. Or if you don't you ought to. You lack experience."

"Experience!"

"*Recent* experience," the inspector qualified. "Sorry, but it's off."

Park stood very still. The sweat ran down his cheeks. His jawline hardened. A rescue man awaiting orders summed up the situation. He thought, "Hard luck, but he's an admin type now. An executive. And they'll keep him in his place, or at least they'll bloody well try to."

Deputy Director of Labour? A pit boy would fare better! Small chance he would have of risking his precious neck!

"But I must go through," insisted Park. "I've seen Lord Balfour, McCardel and the rest of them. They know all about the plan. I tell you I *must go*."

"Sorry," replied the other with equal firmness. "You mustn't. Not unless my superiors confirm their approval to me personally."

"Speak to you personally? But they *can't* . . . Even I know that!"

There was no direct contact between the Fresh Air Base and Surface HQ. Telephone lines had been laid, but were not continuous. They were in sections linking vital points. Runners covered the distance between phones.

"It's impossible," Park repeated.

"Well, there you are," shrugged the inspector. "It's a job for the rescue men. I've said I'm sorry, and I really am, but, well, there you are."

Though a fairly tolerant sort of man, David Park possessed a stubborn will and an impressive temper when he was thwarted. Listening to the blow-suck rhythm of the fans and beat of the flame-proof engines driving them he knew that his purpose would be defeated by anger. Stewart, the inspector, the rescue brigades, he himself were allied against the Thing crouching in the dark gallery ahead. The battle was too big for them to bicker.

"I think," he said quietly, "that I'd better explain in detail."

Discussion followed. At last there were second thoughts.

"All right," agreed the inspector, "though I'm still not happy about it. You can go in as the sixth man of the next team only provided that you come back with the team, as soon as you've had your say. And I warn you, it won't be a picnic."

While Park was preparing for action at the Fresh Air Base, Houston, perpetually awake, continuing his telephone vigil in the West Mine, in the blustering wind Paton pursued his battle with the crater in Wilson's field. The officials at HQ were anxiously studying the report on the gas-dispersal effort. Lesser folk gave supernumerary support to the Knockshinnoch drama.

The canteen staff felt almost dead on their feet, yet there were no grouses. Some women had been on duty for nearly thirty-six hours. Still they refused a break. There was no space for sleep : none to sit. The multitude to be fed increased every minute.

There was a sudden backward surge from men beside the counter. The crowd packed behind was thrown into confusion.

"Hey, who are you pushing? You've spilt my ruddy tea!"

The angry mood passed as someone said : "One of the girls has fainted. Give her some air."

The Welfare Officer arrived to state briefly :

"She's been on duty since Thursday night—working all the time. Wouldn't go home to rest—insisted upon keeping on."

There was a murmur of sympathy : rudely interrupted.

"Let's have some service," snapped an impatient southern voice. "I want tea and sandwiches quickly."

They glanced resentfully at the newcomer, but made way for him. One of the staff pushed a mug along the counter.

"But, that's no use to me. I shall want one of you to carry a tray!"

The Welfare Officer turned from the unconscious girl. "Hey, steady there! Can't you see we've some trouble?"

"I'm ordering refreshments for the conference," came the

somewhat pompous retort. "I *must* have a tray. You don't
expect high officials to carry this stuff themselves?"

"Now look here, we've just had a girl collapse through sheer
exhaustion."

"Really?" the other said languidly. "I don't see why *that*
should keep Lord Balfour waiting."

Less than three minutes later the Top Brass of HQ doing
their earnest best to solve the problem of firedamp were con-
fronted by an irate Welfare Officer. "A tray of tea and nice
thin crockery. Sandwiches neatly quartered and someone to
carry a silver tray! I won't stand for it! It's about the last
ruddy straw."

Only the tact of Balfour and his associates restored calm over
this literal storm in the teacups.

"It won't be a picnic," the inspector had warned them.

Park gave his Proto a final check-up before pushing his face
into it. The sour stink of the workings faded to be replaced by
the sweet, sickly smell of hot rubber. This in turn faded as he
adjusted the nose clip, blew from his mouth and felt oxygen
flow from the steel tube on his back, filter through to the
breathing bag, and rise into the mouthpiece.

"The apparatus is of the self-contained or regenerative
type . . ." In lectures to students on safety courses Park had so
often defined the Proto's make-up that the prosaic words
returned to him automatically.

"After each breath the carbon dioxide is extracted from the
exhaled air and is replaced by oxygen, thus enabling the air in
the bag to be breathed over and over again. . . ."

The theory was so simple that a wit had once described the
Proto as "one big yawn from start to finish".

"Happy?" someone asked.

Park nodded, blew again, raised competent hands to tighten
the straps around his face and helmet. His fingers tipped the
cool metal at the end of the tubes to the breathing bag, slapped

on to the bag itself across his belly, then gripped the ring-handle of the safety lamp. He was ready for anything now.

In single file the team passed through the panel of damp sacking forming a gas blanket to protect the base. Quite suddenly they found themselves alone. They moved in dark solitude through the empire of gas.

The 400-yard lap to the rescue hole was covered with painful slowness. The floor was a chaos of tumbled stone and coal: should a man try to steady himself against the walls they shed pieces of their surface. But it was the danger in the low-hanging roof that worried them most. It sagged on rotted timbers over their heads; perpetual reminder to proceed with care. The clumsiness of anyone could cause a serious fall and render the entire rescue effort meaningless. Tilt the delicate balance between themselves and the men they were struggling to assist. Prudence was essential. Instinct was to hurry yet the team had to move slowly. Their feet barely showed in the dimness of the lamps. Every inch had to be felt with care.

On Park, unaccustomed recently to the hard sweat of rescue work, this halting progress imposed a particularly severe strain. But as the team slogged to the barrier, pausing briefly before commencing to clear the stopping, his physical weariness held dogged satisfaction. Too late for anyone to have second thoughts about the wisdom of his journey. He was safely beyond recall. Bar accident on the route, nothing could halt him.

The temporary stopping in the rescue hole was a brattice heaped with coal. The encumbered men had to shift it with hand and shovel. Park did his stint with the rest. The shovel crutch burned his wet palm with long forgotten sensations. To his long, unpractised eyes the hole appeared smaller and more forbidding each time he looked at it. "Anno Domini or dizzy funk," he told himself ruefully, trying to explain this optical illusion. The hardiest members of the team found the hole more cramped than they expected. Hand over hand, legs

stretched out behind them, they edged forward with grim effort; masked and burdened, graceless as frogs. The roof was only coffin-high above them. The walls were almost as close as the sides of a single bed. Each move caused a man to pant and strain. Each rest was without comfort, inviting claustrophobia. Back, chest and shoulders were strained by the slow crawl. Their knees and elbows rubbed uncomfortably along the glassy floor.

Four feet wide and two feet high was this man-made slit. As a lad Park had wriggled along even smaller approaches. Toiled in cramped workings—"narrow places" in the seams. In his thirties he had demonstrated how rescue teams could make similar manœuvres, even while laden heavily as they were now. But he had to admit that this trip had an unpleasantness of its own. Then suddenly when he felt he could stand no more of it, the worst was over. The beam from his lamp—straight as a spear when confined by the hooped embrace of the coal—widened, diffused. They were entering the broader belt of darkness marking the wider Knockshinnoch road. His relief was almost overwhelming. Talk of a camel through a needle!

A few moments after emerging the six men paused to straighten their bent spines and adjust their kit. They stared at each other and at their surroundings—so long imagined—with eyes that watered beneath filthy brows. Their broken-nailed fingers scraped off the wet muck from their breathing bags. At a signal from the captain they stumbled back into line to start the final slog of 780 yards, uphill all the way, taking them to the Dook, and thence, God-willing, to the West Mine. Though Park's muscles protested his spirit was calm. He had not let anyone down. He had not been "a goddamn' nuisance". He would soon be with the trapped men. Ambition became reality.

"Wake up man, team's coming up from the Dook."

"Eh?" (still half asleep) "tea did you say?"

"*Team*—rescue team."

"Much obliged, but I'll believe the rescue part when they damn' well get us out!"

Park released the clips that had squeezed shut his nostrils; freed mouth and chin from the sticky mask. He sucked in the foul reek of coal and stagnant water with the enthusiasm of a holiday-maker sampling ozone. His head felt muzzy and he had a crick in the neck, but it was good, damn' good, to breathe without the Proto, however vile the odour.

"So we're here!" said the man in front. Trite, perhaps, but a feeling that ran deep.

Park nodded still breathless, and blinked around him at a now historic landscape. The brattice erected by the firemen to contain the gas from the top of the Dook was behind them. Up the slope ahead two cap lamps bobbed, for all the world like lighted buoys on a slow sea swell.

"It's *them*," exclaimed the captain, "they're watching us from the entrance to the West Mine."

Park's sense of achievement in the trip disappeared. He had to plan for the future.

Houston came forward, lithe, quick-moving, almost incredulous. "It *can't* be—but it is! It's Mr. Park!"

He extended his firm hand, his voice half-choked with warmth. Despite their long friendship and the present setting he was careful to stress, in public, Park's formal rank. Park noted the "Mister" with inward amusement. Of course Andy was right. Discipline would do no harm.

"Well, there's no one I'd rather see here than you," continued Houston. "Though this" (attempt at humour) "is not perhaps the time and place to say so!"

"We've known each other a long while, Andy. Just thought you might like some help."

Men emerged from the shadows, restive, not understanding.

"What's happening now? Gie us the bloody news. . . ."

"*This,*" Houston answered, "is Mr. David Park, the Deputy Director of Labour. It's probably unnecessary to introduce him any further . . ."

"*Davy!*" came the astonished voice from the back. "Has he gone stark staring mad!"

At Fresh Air Base Stewart glanced at his watch: "With luck they'll be there by now, though I don't envy Park the explaining he'll have to do. And fancy, the firedamp is little clearer than it was when he left us. All that damn' time gone by and yet we've so little to show for it."

"Still thinking we may have to use breathing apparatus, Alex?"

"Aye, even though the risks are tremendous."

At headquarters there was continued reluctance to write off the gas dispersal plan.

Houston asked, aside: "What are you going to tell them?"

"Nothing that's terribly dramatic, I'm afraid," Park answered, "but I thought it might be useful if I explained about what's being done up top and how everyone is doing his damnedest to make progress faster."

The oversman's voice sounded doubtful.

"Aye, there's a lot of difference in your coming here special to talk to them and someone telling them from a seat beside the phone . . . *but* . . ."

"Out with it, Andy. "What's on your mind?"

"Well, the fact is, man, they've been so patient for so long that it's no wonder a few of them are nearing breaking-point. One or two are just a wee bit bolshy. Do you think the surface will have something concrete to offer?"

"Andy, but I don't need to tell you. It's the gas. There's a hell of a slice to be cleared, so they just have to keep steady."

"Keep steady!" There was a gloomy pause. Houston

recovered himself quickly. "I'm sorry," he said, smiling again. "And you've just finished that long, long walk!"

In the past, as a lecturer, David Park had acquired the reputation of being clear, concise and convincing. He endeavoured to be so now. His speech, short, cool, matter of fact, helped smooth ragged nerves. But when he asked for questions a discordant note was struck.

"Why do we have to wait for the gas to clear? Why can't they send us breathing apparatus?" a miner queried, sensibly enough.

"He's right," chipped in another. "If we had the Proto we could walk out of here as easily as you walked in."

Park explained the complexities of the respirator. The impossibility of its effective use by untrained men. He endeavoured to convey reassurance about the intentions of the "top." As he pointed out: "They're not missing any chances up there." He mentioned that the use of an alternative apparatus was under discussion. But though in general his questioners seemed satisfied, there were a few derisive comments from the fringe of the crowd.

Ignoring these he repeated his plea for restraint. "They are doing their best. We'll just have to be patient."

"*We!*" The emphasis was derisive. It stung.

"Yes *we*," snapped Park.

"Well, the bloody management looks after itself, that's one thing sure," the heckler jeered.

Park silenced the hubbub. "Just what do you mean by that?"

"That *you'll* be all right," commented the critic. "Oh, it's nice of you to come here, but you won't be staying long. While we're playing patience you'll be back safe and sound on the surface!"

"You bloody fool! You poor bloody ignorant fool!"

There was a stunned hush as the Deputy Director deliberately unhitched the Proto, easing himself from his

harness. He dangled it before them a moment, fondling it with hands that—earlier so white and manicured—now were scarred, filthy and a-twitch with their owner's anger. Thoughtfully he stroked the apparatus as if curious to test its weight and construction. After a quick glance at the silent men before him he hurled it to the ground, saying :

"I'm not going back with the team. I'm staying down here with you. If you don't get out, then I won't either."

"Hell . . . I didn't mean any harm."

Park waved the man aside. "I hope I've made myself clear. Anyone else like to complain ?"

Delay . . . delay . . . delay . . .

At the Fresh Air Base Alex Stewart, tense-faced in the glare of the emergency lighting, snapped, "I told you before and I'll tell you again, if we can't get the men out by breathing apparatus, they may never get out at all."

The rescue team had returned minus Park. Their account of the Castle position was far from cheering. They had replaced the rescue hole stopping. The gas continued seeping through into the workings and probably would increase, drawn up with the air escaping through the crater.

"If we can't get the men out by breathing apparatus, they may never get out at all."

MacDonald arrived back on duty to reinforce Stewart's arguments. The fans encountered difficulties. They seemed to be doing little more than recirculate the foul atmosphere, drawing it from one point, depositing it in another.

"The more firedamp we clear, the more it seems to come down on us," said Mac. "The Salvus *must* be used, even though I hate to say so."

The last part of the sentence was a masterpiece of understatement. MacDonald was frighteningly aware of the hazards of employing untried apparatus. The complex problems of an organized exit. Haunting him always was the hideous

possibility, King Charles' Head of all rescue discussions, that some untrained men might panic, barring the narrow rescue hole with their bodies. For by speeding up the breathing the Salvus was rather a scaring device when worn for the first time. Of equal concern was the problem of the apparatus's very limited endurance. Its "life" was thirty minutes. The walk from the West Mine to the Base might take, on average, twenty-five. There would be no margin for accident or delay. What, too, it there be insufficient sets? He had only eighteen Salvus's underground. Many more had arrived at Surface HQ from various different sources and in such haste that they might not all be serviceable.

Despite such grave misgivings MacDonald urged the use of the apparatus—pointer to his disillusion over the Bank No. 6 gas-dispersal plan. Not yet authorized from the surface, Stewart, MacDonald, and Richford, the Mines Inspector, nevertheless began to draw up a working programme.

They decided that the safest thing would be for two rescue workers to accompany each Knockshinnoch man on the outward journey. Rescue teams of six would enter the West Mine in rotation. Each team would be responsible for bringing out three of Houston's party. The planners calculated that this system of close escort should give the men confidence and help prevent panic. Also it should assist them to cover the ground faster. The operation would be "controlled" in a disciplined form. The disadvantage was the considerable time it would take to complete. Even if all went "according to plan" at least forty hours would elapse before the last of the survivors could hope to approach the barrier.

"Forty hours?" an official queried. "Do you think they can last that long?"

MacDonald said: "It depends upon their morale and the state of the gas. *If* they stand firm, *if* the gas gets no worse and *if* they get regular food and drink, I'd say we've a chance of saving them. But, mark you, it still will be touch and go!"

They thought of the present plight of Park. He had no right to disobey orders, but glory, what a man!

Macdonald said: "Should we go through with the Salvus plan there's no doubt at all that he'll be of terrific service. Knowing the apparatus, he'll be able to give the men confidence and practical help. He's taken a hell of a risk, but it may hold the men together. I've a hunch," he added softly, "that we'll have reason to be grateful for Mr. Park's private mutiny."

Four hours had elapsed since Park first sniffed the heavy air of the West Mine: four hours of anxiety and strain. His decision to remain profoundly impressed the men. So had a scathing attack, delivered by him, on the remaining agitators favouring a dash through the gas belt.

"You'd never do it," he said. "You wouldn't last a minute. Just a dozen breaths of that stuff and you'd find yourself in eternity."

When the clamour again arose he shouted: "I am ashamed of you, completely disgusted! I never thought to hear New Cumnock men talk such bloody dangerous nonsense."

It was a crude comment, not strictly true, since Park understood the hard feelings of the rebels. They were not due to cowardice. No "coward" would choose to chance the gas. The frustration of inaction was what had upset them. They sought to batter their heads against the walls of the cell, whatever the consequences. Somehow they must be checked. If sweet reason failed, maybe insults would succeed.

"I'll poke you under the jaw," he snarled at one man, without having to put the threat into practice. The fellow was silenced by his mates.

"If Dave Park's willing to stick it out down here," they observed, "then you ought to be willing, too."

To others the official showed less belligerence.

"The papers are full of Knockshinnoch," he told them. "The

whole world is watching. The people on the surface know what they're doing. Difficulties or no, they're not going to chuck our lives away for the sake of a rash gesture, or because we're getting impatient. What will a few hours matter? Damn all, when you come to look back on them!"

Such arguments, reinforced by Houston's own, together with the steadfast, enduring fortitude of the vast majority of men, carried the day. Passions quietened, if appearances could be trusted.

Though so assured in word and behaviour Park was far from confident. To know all—or nearly all—of the problems besetting those in charge of operations was a doubtful advantage. It did not make for tranquillity. Knowing as much, he feared more. He could delude others but not himself. He did all he could to disguise his worries. Give his audience the bright camouflage of Hope.

Only to Houston could he confide his troubles.

"Candidly, I don't think they'll ever shift the gas. They've tried so hard for so long and still had no luck, that I think it's there to stay."

"What chance of the Salvus, David?"

"Well, as I said, they were talking about it when I started off, but the difficulties are frightening. The thing's simple only compared with the Proto. Apart from that it's complex and unpleasant to wear, until you get the hang of it."

Houston gave a tired smile. "According to you, though, there won't be much alternative?"

"It rather looks that way."

"Well, I wish to God they'd make up their minds!"

At 8 a.m. Saturday morning Stewart pleaded afresh with the surface officials to approve evacuation.

"Have one last try with the fans," they answered.

An hour later he was on to them again. "Sorry, but the fans

are next to useless. I suggest you get started with the Salvus right away."

"Are you certain there's no alternative hope?"

"No hope at all," he answered.

At last came the decision for which he was so anxious. "Go ahead."

Knockshinnoch's call for breathing apparatus and additional rescue teams was promptly answered. The Admiralty offered to send a motor-launchload of Salvus sets to Wemys Bay. The U.S. authorities made an equally important offer of a planeload from the States. Ordinance depots, naval stores, fire stations all supplied their quota of equipment. With Ayrshire's reserves of trained manpower already at the pit, Lanarkshire mustered rescue brigades.

At first it was hoped the news of the operation could be kept quiet locally. It was felt some relatives might become falsely optimistic. Those knowing something of the hazards might become despondent enough to arouse alarm.

An operation of such magnitude could not be hidden. Soon the crowd at the pithead swelled to twice its previous size. Not all new arrivals were from New Cumnock. A harassed officer of the County Constabulary, "drafted" from his home thirty miles away, was astonished to see one of his neighbours.

"I wouldn't have thought that you'd have come here to gawk," he said with feeling.

"Gawker yourself," the other replied angrily. "I'm just back from work on the crater!"

Another arrival, pressing for service underground, proved a Durham miner who had paid his own fare.

"Thought about it down in pit," he explained laconically. "Then took train up north as soon as I came off shift."

Tragically concerned newcomers were the Walker wives, Betty and Jessie. No longer able to comply with the official request to stay at home, they stood, side by side, watching the

rescue teams go down. They held to their determination not to shame their menfolk by crying—crying in public. But their taut lips and tired faces betrayed unshed tears.

"Poor lass," said some loud-spoken fool or other, noting Jessie's figure. "To think that her bairn may be orphaned before it's born."

10

THE LAST HOPE

MACDONALD and his associates had everything prepared. It would take each team about an hour to make the return trip from the Fresh Air Base to the West Mine. Half their oxygen supply would be in a reserve for accidents. They would carry spare Salvus sets. A rescued man might tear off his apparatus or its supply might become exhausted. Doctors, equipped with reviving gear to deal with gas cases, were available at Fresh Air Base. Blankets, too, to warm the shocked living and hide the dead from view. Nothing was forgotten by MacDonald's devoted group.

Despite all the detail the operation involved hazards capable of upsetting all pre-arranged plans. The Salvus had not yet been used underground; they wanted "a guinea pig". A rescue man was to act in this capacity. He would travel to the West Mine wearing the Salvus in place of his Proto issue. The proof of the reliability test would have limited value. "Basic reliability" of an apparatus when used by a trained man was one thing; its "basic *suitability*" for untrained ones was another. Though a stranger to the Salvus the rescue worker was used to breathing apparatus. His reactions en route might differ radically from those of the Knockshinnoch men.

Another problem was ascertaining the exact position of the Knockshinnoch side gas. Outgoing survivors would not then waste precious oxygen by drawing upon it before its use was necessary. Yet MacDonald reflected that the gas was unlikely

to remain static. Each time the barrier was opened firedamp would creep farther into the workings. The fans could not cope with it.

Surface HQ relayed Park's phone request for food and drink. MacDonald promptly dispatched a team with sandwiches and chocolate. He awaited the men's return with impatient anxiety. Much depended upon their eye-witness reports. Especially the moment for going ahead. Much? Might be everything.

He strained his eyes towards the black mouth of the Knockshinnoch road, apprehensive of delay. Forty hours to carry out the operation : forty hours . . . a hell of a time ! It turned his stomach to consider what might go wrong during those hours.

Houston reported that Gibb McAughtrie was in a bad way.

"So's Currie. If things don't hurry up they'll both have to be *carried* out."

"That's going to be damn' nice," Park answered in alarm. "I'll take a look at them."

So far young McAughtrie, the Bevin Boy, had borne up pretty well. Quite suddenly, however, physical exhaustion and mental strain reduced him to helplessness. Rambling aimlessly about his wife and parents he tossed and turned as if with fever. With burning hands he pushed aside the blankets his mates had heaped over him.

The sixty-three-year-old Currie had been one of the stalwarts of the Castle crowd. He had done his stint with the rest; never once complained. The asthma he tried so hard to conceal suddenly betrayed him. He struggled wildly for breath.

Park turned to another man, who lay listlessly against the wall. "You feeling all right?"

"Aye, apart from this damn' thirst. I could drink Loch Lomond dry."

Park sympathized. His own lips were cracked and sore. Water—then he remembered.

"I remember now. One of the teams sent to us earlier dumped the water they were carrying for us on *our* side of the barrier. Just beside the hole : a sort of cache."

"Might just as well have stuck it in the bar back home," grinned the miner, "for all the good it's likely to do you and me. The place is now lousy with gas."

"But I've got a Proto," Park reminded him.

Relieved, he hauled on the apparatus and started walking down to the Dook. He was glad to be doing something useful and on his own again. When he reached the bottom of the slope he realized how fine was the dividing line between himself and safety. But he had made his choice.

Dank darkness, silence, for a few minutes he probed and peered, grotesquely shadowed against the pale cream wash of the lamplight on the cavern's ink-black walls. He found what he was seeking. Gleaming from the heaped dust of the floor were nearly thirty bottles. He was exhausted but triumphant by the time he had effected "delivery".

"By rationing the stuff," said Houston gleefully, "we'll be able to hang on for days."

It was a crass remark, they said later, flying in the face of Providence.

It was David Park who found the firedamp, less than fifty yards from the trapped men. Firedamp now seeping into the West Mine itself.

"Three to five per cent. strength," he later confided to Houston. But for the moment Park was too horrified to talk about his discovery; knowing what it meant in terms of life or death. Within twenty hours the West Mine would be gassed-out.

What could be done? On arrival he had sought to persuade

the men to stay together in the station, to leave the telephone clear of eavesdroppers. But despite his ruling the telephone was a poor security risk. He dared not broadcast his discovery through the West Mine. Yet he *must* find a way of warning the surface.

A voice called from the shadows. "Mr. Park, do you know when we'll get some food?"

Roused from grim reverie he answered half mechanically, "Oh, there's not long to wait. They're sending in a team." It occurred to him that there lay the solution to his problem. He would pass on word to them. Tell them to do the explaining on their return to base.

A little later, when the rest of the trapped men surged around six new arrivals burdened with sandwiches and chocolate, Park pulled the team captain aside to give the message for Mac-Donald.

"Tell Fresh Air Base," he finished, "that I daren't talk over the phone. Whatever they think they can do I hope they'll do quickly. Otherwise it's going to be too late. We'll be dead."

"Oh, my God, *no!*" MacDonald cried.

The men of the rescue team, shoulders sagging with defeat, had emerged from the darkness and firedamp. They slumped exhaustedly around him in the pale light of the base. Jaws still sweating from the rubber mouthpieces. Noses smarting from the pincer-grasp of the Proto.

The news of Park's discovery was the very last straw.

The team's captain added earnestly, "I tested, too, of course. There's no doubt about it."

"Oh, my God, *no!*" repeated MacDonald. "The one thing that remained to go wrong."

To his colleagues also the gas build-up seemed momentarily the end of everything for which they had worked. Assuming the situation did not take a further turn for the worse, the

rescue time available had been cut by half. Their finely calculated schedule could not be improved upon: it left no time with which to play. Impossible to work faster. The plan was dead—stone dead!

Abruptly MacDonald pulled himself together. He turned to Richford and Stewart. "Now *that's* written off we must find another way."

Each official was dominated by a sense of unreality yet dire urgency. Theirs was an awesome burden. Upon the deliberations of three jaded men, dogged by defeat, depended the lives of those in the West Mine. Not to mention the future of the women and children awaiting news on the surface.

The trio were appalled by the inability of planning to achieve results against contrary luck. The task of finding a way out of this latest catastrophe seemed almost impossible.

"That idea we talked about earlier," MacDonald said suddenly. "That plan to establish a human chain. There's no course left but to try it. Despite the danger. That is," he added grimly, "if they'll let us!"

The chain plan, shelved after brief discussions, had envisaged the establishment of a static "chain" of rescue teams extending through the gas-filled area from Base to the Barrier. Emerging single file, the trapped men would then run the gauntlet, so to speak. Pass along a roadway lined by skilled workers, ready to assist them through the difficult journey. At the same time any tendency to panic could be checked. Yet despite apparent advantages the plan barely had been touched upon.

The risk in the chain scheme was too high to be acceptable whilst any workable alternative existed. It meant exposing rescue men to operational hazards in a foul atmosphere for the duration of their Proto's two-hour "life". The extreme length of the chain, eight hundred yards, increased the possibility of accident, both to the human links and those they strove to save.

As officials discussed the project they knew that every second of debate was one sliced from the working time that remained. A second nearer to the crisis when the West Mine filled with gas, becoming a tomb to its inhabitants. MacDonald spoke on behalf of every man working with him.

"Desperate disease, desperate remedy."

The details of the "chain plan" (new edition), were agreed between the three officials in a matter of minutes. Whether the "top" would be equally prompt endorsing it was questionable. The plan, as it now emerged, was startlingly novel. Depressingly hazardous. It was decided that Stewart should return to the surface to argue personally with the authorities.

"For otherwise," said MacDonald grimly, "they may *never* clear it. It's against everything the book of rules stands for. It's the very last resort."

The Last Resort? Hurriedly gulping the fresh morning air Stewart emerged from the mine-mouth and set off for the conference. He bore the defiant look of a man expecting opposition. He literally bristled with aggressive determination. The plan must go through!

"But it *can't*," someone argued, "it's against Rescue Regulations."

Snappily Stewart answered: "But it *must*."

"But it's too dangerous, far too dangerous. Let's try another way ..."

Stewart answered: "It's the *only* way—everything else has failed."

The officials had all the doubts that Stewart and MacDonald expected. Nor were those doubts ill-founded. Never had there been a rescue project of such magnitude and risk. At least one hundred skilled workers would be required to form the "chain", and each would be in jeopardy until the job was done. A chance spark, a roof-fall, a defective lamp ... Let any one of these accidents occur and the company of Castle

men and rescuers could be written off. Who wanted to shoulder the responsibility for *that*? Electrical teams, repair squads, first-aid parties would be needed in the Bank Mine to meet demands of the "chain plan". Surely there must be another way to save Houston and his men? One involving less danger to so many?

Stewart insisted: "There *is* no other way . . ."

"But the existing scheme, the one we've so recently agreed? —couldn't it be speeded up?"

Stewart explained, all over again: "Just can't be done . . . we could only hope to get half the men out . . . half at the very most."

A miserable silence followed. On one side was morbid fear of inaction. On the other, fear of action itself. There was no precedent for its risks. The moral dilemma was difficult to decide. Its legality, too. Several officials felt that adherence to regulations was binding in law. If so, they could be held legally responsible for any violation. If things went seriously wrong they might be open to a criminal charge. But regulations were made for men, not man for regulations. If Stewart was really *sure* there was no alternative . . .

When officials finally consented it was with profound misgivings. They felt sentiment had been mainspring of their action. As a practical business the scheme lacked appeal.

Betty Walker glanced at Jessie, pity for her sister-in-law briefly lessening her own torture.

"There, Jess, don't take on so. It'll be all right. It must be all right, for the sake of the baby. Walls will come back."

Jessie stared dry-eyed at the pithead crowd. She answered dully, "Willie McFarlane's wife had her baby yesterday. Willie was working in No. 5. They say there's little hope for

the men in No. 5. They say that the sludge never gave them a chance."

Down in the West Mine McAughtrie's state worsened. The lamp placed beside his head failed to alter the blankness of his eyes. Pillowing the Bevin Boy against his knees one of the men said grimly, "He'll be a bloody goner if they don't get us out soon."

"Not so loud. He'll hear you."

But McAughtrie was beyond hearing even his own delirium.

Houston arrived. He regarded the scene with compassion tempered by knowledge of how such breakdowns of health could hamper the mobility of the company in the event of rescue.

It was nearing noon. Aware of the increasing gas menace Park found it difficult to keep up his pretence of well-being. That he contrived to do so was a thing he marvelled at later. He made no claim to heroism. He could have left the West Mine whenever he chose. Morally he considered that impossible. He could not in any circumstances leave the others, and knew it. At times his Proto, discarded on his return with the water, almost seemed to mock him. Like the others Park had a lot to live for.

He telephoned a report of McAughtrie's condition.

MacDonald never had been a dissembler. He prepared a report upon the logistics of the scheme which was formidable.

Anxious to shorten the distance the men would have to cover before a breather and reaching medical assistance, he decided to create an advance fresh air base 500 feet above the fan. This left 700 feet of foul air through which to pass after negotiating the rescue hole. It was the best he could do. As he somewhat acidly pointed out, it also was the very least. Worn out by sleeplessness and suspense, forced to rely upon equipment terrifying unfamiliar, on average the men might be expected to

take twenty minutes to complete the journey. Their untried
Salvus had an operational efficiency of just half an hour.

"How many rescue teams will you require?" he was asked.

"At least fifteen—fifteen at a time!"

Fifteen teams. To be staked at once? The order sounded
tall.

"It's the *minimum* requirement," he emphasized.

"You shall have them," they agreed.

MacDonald's demands were of necessity heavy. He aimed
at stationing one team permanently in the West Mine to fit
Houston's party with equipment, brief them as to its use.
"Start them off on the right foot." The chain itself, which
would provide confidence and help to the escaping men, also
would pass in extra Salvus equipment. It would cut the time-
wasting process whereby messages between rescue teams and
West Mine had to be routed through Surface HQ. With
human "links" spaced out at thirty-yard intervals and extend-
ing the length of the gassed area from the advanced Fresh Air
Base to the barrier the chain itself would absorb the total man-
power of five teams without allowing "extras" for relief or
emergency.

One hundred and sixteen men would become acquainted
with the Salvus under the worst possible conditions, and the
Protos of the regular brigades had a maximum life of two hours.
These factors weighed heavily with MacDonald, Richford, and
Stewart. Stand-by teams should be available in equal numbers
to those on "chain" duty. So far none had arrived. They were,
however, coming as fast as they could. Meanwhile did they
dare commence the risky evacuation when the "minimum
requirement" was three times greater than existing resources?
They agreed that they would.

They would try to evacuate McAughtrie, then start the
major scheme. As each promised reinforcement man arrived
he would go to the head of the chain, replacing the one in posi-
tion. The relieved man, with his dwindling reserve of oxygen

would return to base to rest for four hours and operate for two.

Fifteen teams! By the time their mammoth task ended they would have used twenty!

Houston knew before a word was said. In fact from the moment Park turned hesitantly from the telephone, restraining his excitement.

"Andy, this is *it*! We'll soon be on the move."

"Thank God."

"It's a Salvus effort. Very much touch and go. But they're starting right away."

Houston said, "We'd best get the men organized."

"Surface is emphasizing how much will depend upon their discipline. How do you think they'll take it?"

"Take it? They'll take it fine!" A shadow clouded the oversman's satisfaction. "But what about our invalids? What's to be done about McAughtrie and Currie?"

"Base seems to have things nicely buttoned up. First arrivals will be a stretcher team."

Houston's forecast of the men's reactions proved correct. When Park announced the news, morale reached a peak as high as when the barrier was first breached. Furthermore, they appreciated his warning that the job would be tedious and difficult. Resigned themselves cheerfully to the prospect of further delay. On this occasion there was no concert party. They had experience of how premature mafficking was followed by disappointment. Yet every man felt vast relief. Whatever the hazards ahead, at long last there was the promise of action.

Houston called the firemen together. "I want you to list the name and age of every man in your section."

This done, he opened the blue notebook borrowed from Fireman M'Knight—his own had been left near the pit-bottom and was buried beneath the sludge. Pulling out a stub of a pencil, he entered the men's names in groups of three.

"My plan is to let the eldest go out first," he explained. "I don't suppose the younger ones will complain."

They did not.

Houston felt almost happy when he had filled the page. The very fact of preparing the roster lent reality to the prospects of rescue. From the abstract to the concrete. After totting up the names to ensure that no one had been forgotten, he made the irritating discovery that he had estimated 116 men in the West Mine, but could account for only 115. He re-checked the names. And then again. The figure remained 115. He recalled the firemen.

"Are you sure you made no mistake?" They compared their lists which tallied.

"Yet it *should* be 116," said Capstick dubiously. "In fact, if you count Mr. Park, it should be 117"

"You're right," agreed Houston. "I hadn't entered Mr. Park. But even so, we're still one missing."

He puzzled over the page, then smiled. "Of course, it's me! I'm the chap that's missing. I forgot to put my name down!"

At 1.30 p.m. MacDonald took a final look round and with satisfaction reported : "We are about to start."

MacDonald's decision to give priority to the Bevin Boy's rescue was influenced by the idea that it would provide valuable data as to the behaviour of the Salvus and provide confidence in the subsequent "chain" effort. Everything seemed to be according to plan. It was not MacDonald's fault that it did not stay that way.

The team entered the West Mine without incident and were enthusiastically received. They wrapped McAughtrie in blankets, strapped him to the stretcher, wasting no time in departure. The sooner they returned to base the sooner the main evacuation could commence. Now, the jovial team leader went further : "You've not long to wait now, lads. An hour at the outside."

A forecast to prove over-optimistic.

Manhandling McAughtrie's stretcher, the rescue team took him, masked, through the escape hole. They expected a rough journey. It proved far worse than anticipated. Owing to the cramped conditions of the route it was impossible to lift the stretcher. Mounted on sled-like runners, it had to be pushed and dragged in a jolting, jarring progress. For all their devoted care the patient's face was in constant danger of touching the roof. At times they feared to brain him. Moving on all fours, in full equipment, they worried about the safety of the youngster. The trip became almost unbearable. There were brief pauses to grope at McAughtrie, making sure his mask was in position and reassure him. There was no relief for their aching limbs in this comfortless confine of stone and coal. Owing to the limited duration of McAughtrie's Salvus they could not rest. Three men were in the team. One crawling; the stretcher in tow. Another pushing. And another, squeezed between the stretcher and the wall, as "close escort", with a spare apparatus. He hoped he wouldn't have to use it as the manœuvre would be extremely tricky under such conditions. Even though the boy's hands were strapped to his side, the jerk of his head might upset the split-second timing dividing life from death.

Yet it was when they thought the worst of the journey lay behind them when they believed that all that remained was the last lap—the comparatively simple journey from the Bank side to the Fresh Air Base—that their worst moment came. So far the discomforts were part of the rescue game. What they had signed on for, so to speak. The unexpected was the collapse of the captain!

After leading them through the most treacherous part of the route—and doing more than anyone to keep the stretcher moving and McAughtrie quiet, he was suddenly overcome. He

slumped on to his face and lay still. One of the men crawled alongside, trying to bring him to, without success. Desperately they then strove to move him. He was a heavy man and there was so little space. Near-panic set in as their plight grew clear. The captain was unconscious, badly needing aid. McAughtrie's stretcher jammed the escape hole and his oxygen was running low. It looked like being a double tragedy. The team's indecision was momentary. Help must be fetched. Could they leave McAughtrie? There just was no alternative. Suddenly a team member grabbed McAughtrie's mask, tearing it off. Almost simultaneously the "close escort" clapped a Salvus over his face and held it there, while the rest went ahead unencumbered. They did not stop until they saw the white glow of lights at Fresh Air Base.

"Hey, what the devil." But they were in the midst of explanations before MacDonald could finish the sentence.

Houston sensed that something was wrong. So did Park and the men.

An hour had elapsed since the departure of the stretcher party. Still no sign of promised rescue. Calm was maintained, but the nervous undercurrents were nearing the surface. Houston decided that he might have to revise his roster. Move some of the youngsters towards the head of the queue, mixing them with older men originally given priority. Not that the young were less good than he had expected—it was just that the veterans were much better than he had hoped.

The younger men had discussed the order of departure. Young Alex Walker, for one, was shocked that he was due to leave ahead of his brothers. He abandoned his self-imposed exile among his mates to demand that the position be reversed.

"You're married and with children," he said, "I'd be shamed if I got out before you."

"But you're our wee brother," they teased. "Women and children first!"

"But how do you think I shall hold my head up if anything happens to you and I have to face Jessie and Betty?"

"And how shall *we* face Pup, if you don't come home?"

Another half-hour elapsed.

Commenting upon the brothers' argument one of the men said: "I don't think it'll matter either way. Something's gone wrong."

Meanwhile at Fresh Air Base consternation had been replaced by action. A rescue team was rushed to the barrier with two spare sets of Salvus. When they reached the Bevin Boy he had less than five minutes' reserve of oxygen. One man forced off McAughtrie's mask, the other clapped on that of the spare set and help it over his face. A Novax apparatus was used to revive the captain. The other Salvus was employed to bring him clear of the gassed area. Soon he and McAughtrie were in the doctor's hands.

This mishap had proved costly both in time and manpower. The rescue took nearly an hour and a half. All five available teams had been used. The planning schedule was upset. Operations now had to be halted pending reinforcements. MacDonald was in a fury of frustration and almost inconsolable until someone pointed out:

"Anyway, it's proved one thing that's good—there's little that's wrong with the Salvus."

He brightened. Yes, it *had* proved the Salvus which, after all, was a major achievement.

"One hundred more volunteers needed to help in Bank."

No sooner had the buzz gone round than there was almost a free-for-all amongst the men at the pithead. All were anxious to go below: all equally anxious to assist.

"I haven't a belt to hitch my lamp to," shouted one of the selected. "Will someone lend me a belt?"

In a moment dozens of belts hurtled through the air.

I I

THE ROAD HOME

THE sirens shrieked as McAughtrie reached the surface.
A great wave of joy ran through the anxious crowd.

As proof that vague hope could become reality, he
lay on the stretcher staring at the light, tingling from the moist
breeze. He was too weak even to wave. Almost he was in tears.
He was able to talk a little, but, mercifully, his memories were
patchy. Despite the harrowing journey out the thing that made
the most impression upon him was a hazy recollection of the
trapped men's voices raised in song.

"My mates," he kept repeating, "they are singing like
linnets."

Realizing the ambulance was awaiting him he started to
protest. "But I want to go home first—to see my wife. I want
to tell her I'm all right."

Firmly they answered: *"We'll* do the telling. Meanwhile
you're going to hospital."

It was 5 p.m. before the main operation was under way.

Scores of volunteer workers squatted along the route between
the bases. Their helmet lights sparkled like fireflies in the dark-
ness. At the main base two doctors and thirty stretcher bearers
were in attendance. Even at the advance base, where another
doctor was available, everything seemed "laid on." Only
luck was needed. There were a hundred spare cap lamps to

replace those exhausted by the trapped men. There were supplies of hot tea and sandwiches : neatly stacked blankets.

Again MacDonald reported : "We are about to start." Again a shadowy file of men marched out of the light into the silent darkness.

This time the team was from Coatbridge Rescue Station. Explicit instructions had been given. They would proceed to the West Mine and remain, if humanly possible, until the evacuation was complete. They would remove their own equipment to give confidence. Brief the trapped men as to the plan itself and use of apparatus. They were laden with spare Salvus sets to fit Houston's men. Additional sets would be passed to them along the supporting "chain" which now formed in their wake.

Meanwhile Park and Houston had completed their preparations. The telephone had been decided upon as the assembly point for evacuation. The diesel engine had been shunted into position near by so that its headlamp could light the scene. Despite such hopeful activity the situation in the West Mine had not grown healthier during the three and a half hours since the cheery promise of the stretcher-party leader. The gas had spread and reached the station itself. It was now hovering only a few feet above the heads of the men squatting in the haulage way. Its lethal content would increase. To succeed evacuation must proceed at top speed.

No sooner had the team settled down to work, than Park interrupted them. "Just a moment, please. I'd like to look at those sets before you put them on the men."

To save weight and allow each rescue worker to carry more than one apparatus, the box containers of the breathing sets had been left at base. Park, with his personal knowledge of the sensitivity of the Salvus, was worried in case the unprotected gear were damaged en route. His fears were confirmed. Several sets were leaking; some were useless.

"Now look at *this*," he said bitterly, dangling a Salvus at

arm's length with the expression of a man with a nasty smell under his nose. "It's not your fault, of course, but there's about enough oxygen left in this to take a man fifty feet into the gas. After that—he's dead!"

Of the many services performed by the Deputy Director of Labour during his self-imposed sojourn in the West Mine, this checking of the Salvus issue was by no means the least valuable.

Wang Carracedo was in the first group scheduled to leave. Physically exhausted, but good-humoured as ever, he joked about the St. Leger until the mask silenced him. James Haddow, Wang's fellow sixty-eight-year-old, and the man whom Houston had met in No. 5 heading, at the start of the disaster, when the conveyor had started to "slide", were other members of the party. A third veteran was Tom Currie, the sixty-three-year-old asthmatic, who had been temporarily revived.

They left in good order. Their nervousness over trusting unfamiliar apparatus was hidden by their grim self-pride. The rest waited in equally good order for their own turn. Each one was aware of the drama of the moment. In the presence of the "audience"—the rescue men—each did his best to appear confident and calm.

When they heard the news, rushed to them along the chain, that "old Wang is safe, he's arrived at base", they betrayed excitement and relief.

Houston said with pawky humour, "If old Wang can do it in fourteen minutes, lads, I dare say some of you will be able to manage it in fifteen!"

By 6 p.m. nineteen of the trapped men reached safety. Twenty had started out, but the test had been too great for Tom Currie. Physical odds were against him. He had been forced to return, panting, struggling for breath.

"Take a rest, Tom," said Houston. "Take a rest and try again."

By 7.20 p.m. twenty-nine men had escaped. Again Tom Currie passed gamely into the gas, once more to be defeated. The long line of lights spun before his dazed eyes. He was returned to the starting point in a state of near-collapse.

"Rest again, Tom," they told him, "and we'll see what base can do."

Base said they would send in a stretcher team led by Douglas Hazell.

Hazell had been equipped with an hypodermic of adrenaline. The doctor who had volunteered for duty at the advance base had given him a brief demonstration of the instrument. Assured him it would prove easy to operate. Hazell was just a shade nervous of his responsibility. Currie was in pretty bad shape.

When Hazell reached the sick man he acted with competence. First he gave him the special pills he needed then, as directed, injected two-thirds of the drug. The pause that followed was apprehensive. Then Tom Currie improved. Five minutes later Hazell had him strapped to the stretcher. The party started on the outward journey.

Half-way to base Tom had another relapse. Hazell hesitated, then emptied the rest of the adrenaline into the sick man. Again Currie revived and was soon in the care of "professionals".

"Do you a swap?" Tom urged.

"Not darn' likely!" answered his brother Walls.

Tom was to be in the next group. He was unhappy about it. Alec was safe already; but Walls staying behind. His name was at the end of the list. He would not make the journey until later.

Tom said: "I don't like it. As senior, *I* should be the last Walker out."

"No swap at all!" retorted Walls. "Big Brother or not, we'll both of us do what we're told."

"But, don't forget . . . You're an expectant father."

"I don't forget, Tom. But I'm not going to take favours."

There was not much more to say.

After waiting for long minutes behind Currie's halted stretcher—terrifying minutes during which the Salvus seemed to choke him—Tom Walker's hurt at leaving his brother gave way to self preservation. His was a fierce desire to reach the top.

When he saw those welcoming lights on the Bank side of the barrier he was almost overwhelmed. Not until he had staggered into the base, greeted by Dr. Fyffe, an old friend of the family, did he realize the nightmare was over.

Having reached the surface, seen Pup and Betty, the brave spirit sustaining him in the pit vanished. He wept.

With the evacuation of the main body proceeding more smoothly than the most sanguine hopes, Surface HQ officials turned to another aspect of the disaster. The fate of the men working in No. 5 at the initial inrush. The men of Strachan's section.

The much-tried Andrew Cunningham had given a faithful account of his lonely race below, including his split-second glimpse of two of the men, thought to be Dalziel and Howatt, "sealed off" in a side turning as they fled for their lives. There was news, too, of Capstick's unsuccessful reconnaissance when he and his party sought a way through via the return airway to find no one. With so many of the West Mine's company rescued and Park and the Coatbridge Brigade controlling the remainder, it was felt that Houston's presence below was no longer so vital. He would be more use up top. He could give expert assessment of the situation. Help establish the last known location of the missing miners.

.

At 8.15 p.m. Houston had word to go. Over half of the men had left. Firty-five awaited their turn. For a moment he felt like disobedience. Having stayed so long and endured so much, he might as well see the finish. However, they said he *must* go. He had done all possible for the trapped. Now his duty was to the missing.

Tiredness overcame him. He felt a hundred years old as he glanced again at the long list of pencilled names. The ticked-off ones of those who had left and the balance of men remaining. His own name was right at the end. That was the way he had wanted it!

Quietly Park reminded him: "It's time for you to go."

The oversman continued to thumb over the pages of the book, turning to the part containing the "Stand Firm" message received from McCardel when their ordeal was still fresh. How long since he, Houston, had repeated that message verbatim? Repeated it, with the ghost-like silhouettes of men around the telephone. The fireman transcribing it. Thirty-six hours? Seemed an eternity!

Abruptly he handed the book over to Park. "Looks like it's all yours now!"

He left with a group of ten and reached the surface at 9.15 p.m.

In his pocket was a bar of chocolate, saved from his ration. He would give it to his wife as a souvenir.

There was work for MacDonald, Richford and others in the tunnels. Balfour, McCardel and the planners upon the surface. The rescue teams, organized mainly by Dick and Moran, from Kilmarnock and Dyer from Coatbridge. Also for Paton at the crater and Rachel Hyslop, running the canteen. All were helping in the Battle of Knockshinnoch. The minute-by-minute entries in the Fresh Air Base log were symbolic as trumpet calls of victory over odds.

The first man to walk through the gas had arrived at the

base at 5.20 p.m. By ten-thirty, seventy-seven were saved. At eleven-thirty only a small group of masked figures waited in the once-crowded West Mine Station. Soon, they too, would be gone.

For Houston, medically examined, there remained the task of conquering his weariness sufficiently to talk to officials about the untraced men in No. 5. His last act for the present would be a brief reunion with Mary and departure to Ballochmyle Hospital. Then would come the personal congratulations of Noel Baker, Minister of Fuel and Power, visiting him at home on release from hospital.

For Walls Walker, half dizzy with the hope of seeing Jessie again yet keeping his fingers crossed—in case—there remained the trudge down to the Dook, exhausting scramble through the barrier and journey through the friendly lines of rescue teams. And hardly crediting his luck, emergence from the mine-mouth into the sweet winds of the outer world. For Walls there also would be a visit to Ballochmyle. Next day he would joke with his wife when she visited him. "You ought to be here in bed instead of me." (Their new baby was born the day after that.)

For Andrew Cunningham, the conveyor-shifter who had risked his life to dash down into the pit at the onset of disaster, that moment when the earth began to slip, there remained the deep sleep of exhaustion. His first sleep in three nights. For modest Cunningham, hating "show", it sufficed that the operation was successful. Not considering himself a hero he avoided the Press. Not a great talker, he had no wish to gossip about experienced horrors. A King's Commendation was later bestowed upon him. Cunningham did not think of honours or reward. His battle in the pit-bottom sludge and unremitting help in the rescue work was past. The present was to go home with Margaret and rest.

The West Mine was almost completely silent. Only one man disturbed its solitude.

The echo of laughter, curses and prayers had long since died away. One hundred and sixteen huddled men had suffered forty-eight hours that would live for ever in their memory. All traces of their tenancy had vanished save for litter heaped around the track. The sludge to the east was motionless. The route to the west could have been thousands of miles away.

Slowly, almost reverently, Park moved amongst the stillness. His thoughts, far from nostalgic, were prosaic and practical. In the excitement of departure some men had left their powder cans behind. Each contained a five-pound explosive charge. Park collected them and put them out of harm's way. Still ignoring the unseen enemy, he gathered up the discarded lamps and next went to the telephone.

"The time," he said laconically, "is eleven-thirty-eight, and I am now leaving."

He picked up his personal gear, adjusted the Proto, turned off the diesel's headlight before proceeding to the surface.

12

AFTERMATH

ONE hundred and sixteen lives were saved in the greatest and most complex mine-rescue operation of all time. Universal admiration for the rescue workers and the trapped men themselves. The George Medal for Houston and Park. Such was the bright side of the Knockshinnoch story.

The dark one was very dark indeed.

Presiding at a subsequent inquiry Sir Andrew Bryan, Chief Inspector of Mines, commented: "The symbol indicating the presence of peat in the field concerned in this disaster was overlooked. A proper examination of the nature and character of the ground in the field was not made."

He talked of "a weakness in organization, in that insufficient arrangements were made to ensure that the planning engineers were kept adequately informed of the subsequent changes disclosed by the progress of the workings in No. 5 Heading Section."

Furthermore, recalling recommendations made in 1938 by the Royal Commission on Safety in Coal Mines, Sir Andrew Bryan added candidly: "Since these recommendations were made the industry has been nationalized and the number of officials between the owner and manager of a mine has been greatly increased. The precise definition of the duties of all these intermediaries is a matter of very great difficulty."

Will there be other Knockshinnochs? The NCB has introduced several regulations in an endeavour to ensure that there

will not. But there always will be mining tragedies, even when all chance of human error has been eliminated. Luck or Fate play their part. There can be no certainty underground. Heroism alone cannot completely redress the balance when things go wrong.

Whilst the world was applauding the success of the West Mine evacuation at Knockshinnoch, Willie McFarlane, who had gone to work in No. 5 on the day his child was born, was one of a tragic thirteen. So were John Dalziel, father of nine, William Howatt, Dalziel's mate, James Houston, Andrew Houston's brother.

Led by Fireman Dan Strachan, their comrades were Thomas Houston, William Lee, James Love, John McLatchie, Samuel Rowan, Park's cousin John Smith, Park's uncle John White, and John Murray.

For these men there was neither rescue nor escape. Yet heroic indeed were the efforts made on their behalf.

On Sunday the 10th two teams of volunteers, realizing there was no hope of reaching No. 5 from the West Mine, attempted the near-suicidal descent through the crater itself. The main body of sludge had sunk lower into the workings. The sides of the heading were coated. Some places were slippery as glass. In others the going was treacherous as a bog. Most of the roof supports had been carried away and there was always the danger of gas.

Yet despite the horror of the trip, despite the practical certainty that most of Strachan's group must have been overwhelmed in the first onrush, despite further falls from the rim and fear of sludge moving, the men, roped together, succeeded in an 800-foot penetration. It was a wonderful feat. Only the fatal luck of No. 5 made their effort useless.

The weather worsened. Rain increased and masses of liquid peat slid towards the opening of the heading, threatening another inrush. After coming face to face with a massive

barrier, from floor to roof, the teams withdrew, on orders. Next day it was decided to halt operations.

When salvage squads were at last able to enter the pit a long while later, they found sombre evidence that two of the missing had not only survived the initial fall, but lingered for days after the rescue work's suspension.

One salvage worker from Houston's party found a clue in his sandwich tin which he had left unopened. Someone had opened it since and not a crumb of contents remained. Even more poignant evidence was forthcoming. It almost broke their hearts.

Messages were discovered scrawled on a conveyor belt, signed by Dalziel and Howatt. The last message was dated September 12th—three days after the main party's escape. Timed six-ten in the evening it bravely informed the horrified team : "Still trying. We intend to make for No. 21 Road."

Every exit had been blocked. The pit became their catacomb.

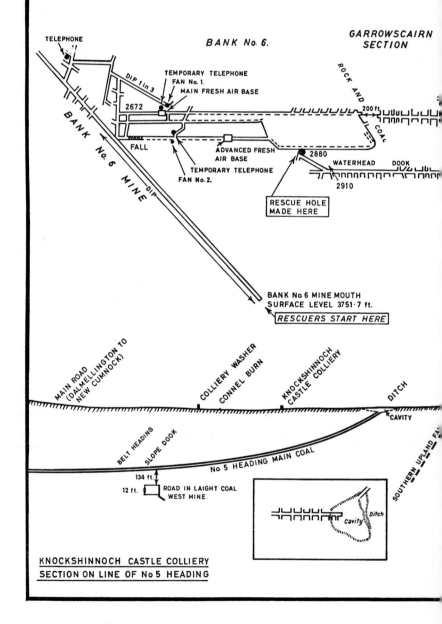

KNOCKSHINNOCH CASTLE AND

BANK No. 6.

GARROWSCAIRN SECTION

TELEPHONE

DIP 1 in 3

TEMPORARY TELEPHONE
FAN No. 1.
MAIN FRESH AIR BASE

2672

BANK No. 6 MINE

DIP

FALL

ADVANCED FRESH
AIR BASE

TEMPORARY TELEPHONE
FAN No. 2.

RESCUE HOLE
MADE HERE

ROCK AND COAL

200 ft.

2880

WATERHEAD DOOK

2910

BANK No. 6 MINE MOUTH
SURFACE LEVEL 3751·7 ft.

RESCUERS START HERE

MAIN ROAD
(DALMELLINGTON TO
NEW CUMNOCK)

COLLIERY WASHER
CONNEL BURN

KNOCKSHINNOCH
CASTLE COLLIERY

DITCH

CAVITY

BELT HEADING

SLOPE DOOK

No. 5 HEADING MAIN COAL

SOUTHERN UPLAND FA

134 ft.

12 ft.

ROAD IN LAIGHT COAL
WEST MINE.

Cavity Ditch

KNOCKSHINNOCH CASTLE COLLIERY
SECTION ON LINE OF No 5 HEADING